A STAR FOR NOON

A STAR

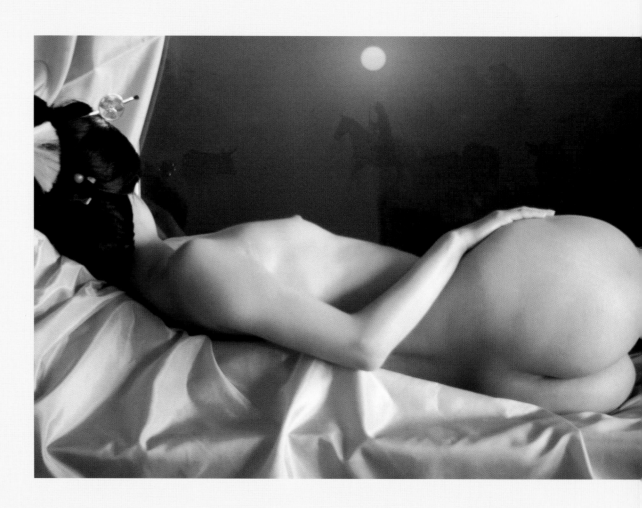

FOR NOON

AN HOMAGE TO WOMEN IN
IMAGES, POETRY, AND MUSIC

GORDON PARKS

A BULFINCH PRESS BOOK

LITTLE, BROWN AND COMPANY

BOSTON NEW YORK LONDON

First Edition

Library of Congress Cataloging-in-Publication Data
Parks, Gordon.
 A star for noon: an homage to women in images, poetry,
and music/by Gordon Parks—1st ed.
 p. cm.
 ISBN 0-8212-2685-1 (hc)
 1. Women—Poetry. 2. Women—Pictorial works. I. Title.
PS3566.A73 S73 2000
811'.54—dc21 99-086225

A Star for Noon Suite
For Chamber Ensemble
Music composed by Gordon Parks
Orchestrated and conducted by Kermit Moore
Gordon Parks, Piano
Kermit Moore, cello soloist
Mario E. Sprouse, producer

Bulfinch Press is an imprint and trademark of Little, Brown and Company (Inc.).

Printed in Hong Kong

CONTENTS

AWAKENING 9

LONGING 31

REMEMBERING 59

WAITING 77

RETURNING 95

HOMECOMING 103

ACKNOWLEDGMENTS 111

COLOPHON AND CD 112

MEMORIES LEFT BEHIND

Recently, while glancing back
through the seductive imagery
of a camera's discerning eye,
I recalled mainly those moments
when the women who appeared
seemed lost in a voiceless past—
unruffled, full of secrets,
and fragrant with silence.

Then, as ages of thoughts
churned inside my memory,
one unshakable tryst emerged—
still relentless but tired
of living with me alone
 and unannounced.
So, free of any enrapturing secrets,
I now, in full cry, release
that affaire d'amour to the winds,
 every ounce of it—
the joy, the pain, and the serenity.
All three arrived in that order,
opened my door, walked in,
and left me peacefully suspended
between yesterday and today.

AWAKENING

THE FIRST BUD

Through winter-locked and hungered days,
and during trials of doubtful years,
I walked mistaken roads searching for you.
So when as you say during pillowtalk,
* you do not know me,*
* remember that I am you.*
We have been one for thousands of years.
Our love is older than the sky.
That love tremored every windflow
while waiting to be summoned
by a cry, a moan from my heart
that was ablaze with loneliness.
Then, with the silence of a cloud,
it emerged through shadowless mist
* and, with pity,*
ripped my outraged soul apart,
then strung it together with stars
that light your peaceful shade.

Now those nights
that were once without splendor
dance in on wings that sing.
And the sound of rain
falling on the roof is joyous.

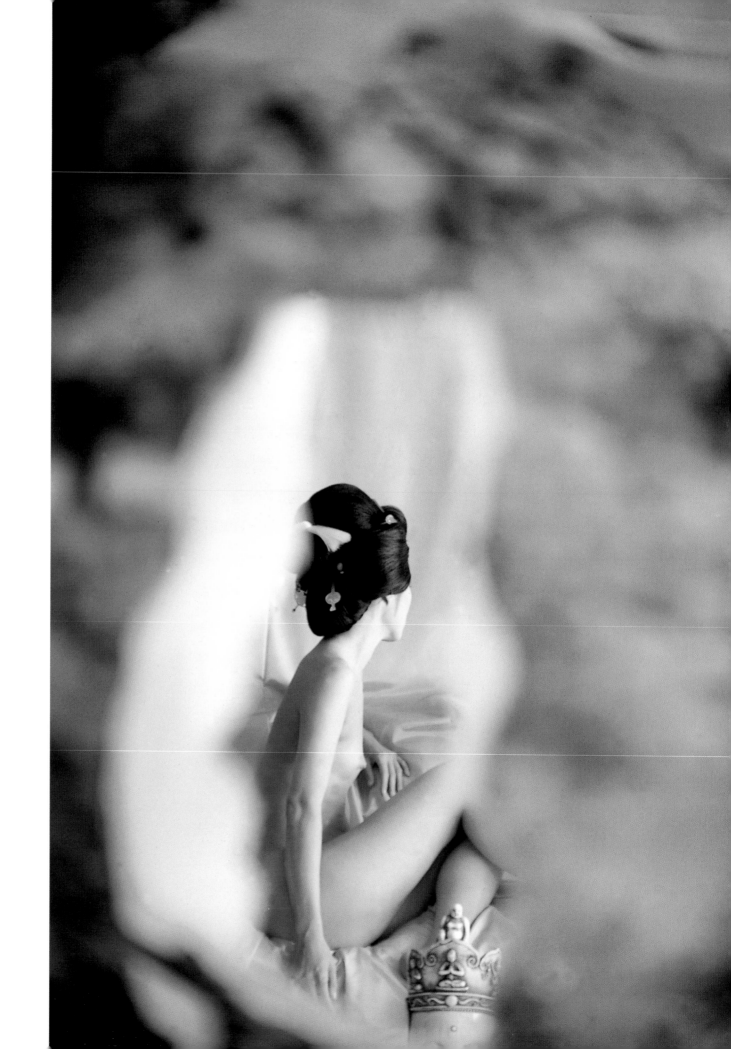

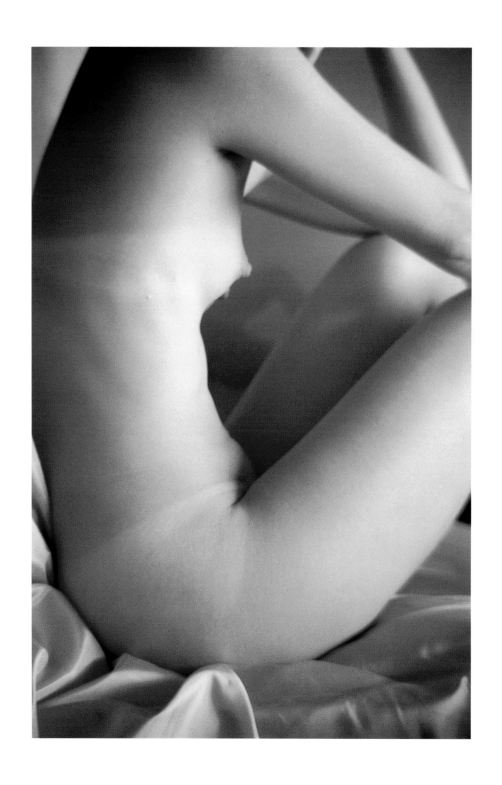

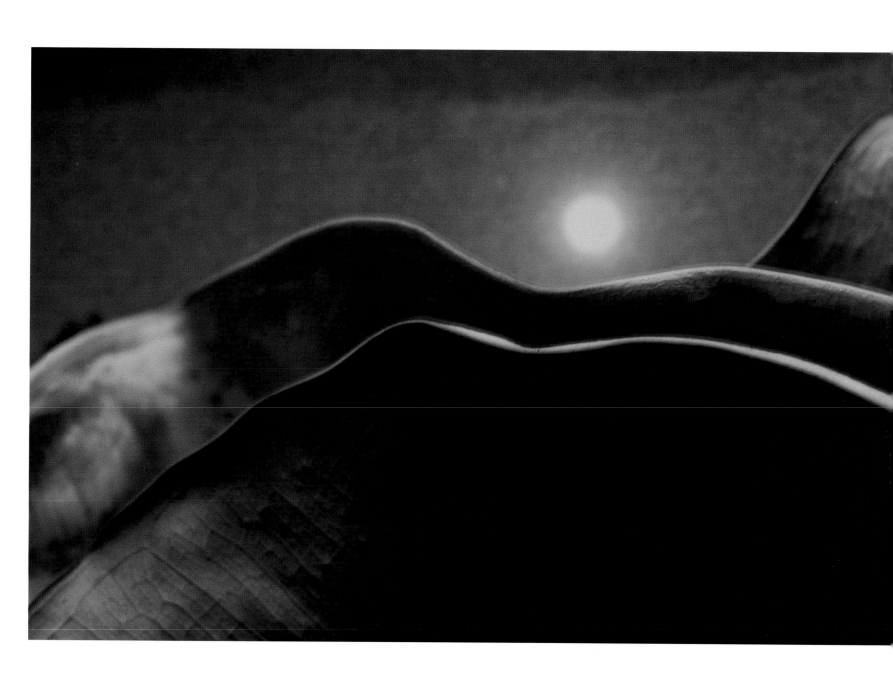

AWAKENING

Suddenly, with the scent of wild honey,

you are like mist flowing gently.

And I, with lips touching your breast,

am puzzled by your little sighs

and those voluptuous silences

that come now and then

during the most ardent moments.

With oceans of years at my command,

I'm no longer a stranger to seduction.

And I've learned to endure its sufferings.

Now it all comes beautifully clear:

while the wildest of my affairs

performed their sporadic dancing,

you seemed to have lingered patiently

inside some restless clock, waiting—

watching my wasteful years

slip silently into the past.

But now, and far beyond this moment,

trust this love burning inside me.

No longer is it just a dream to die

in the light of another dayspring.

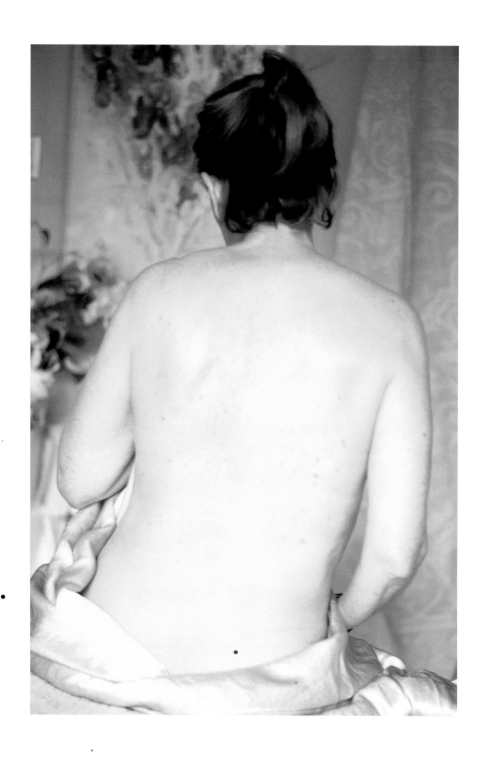

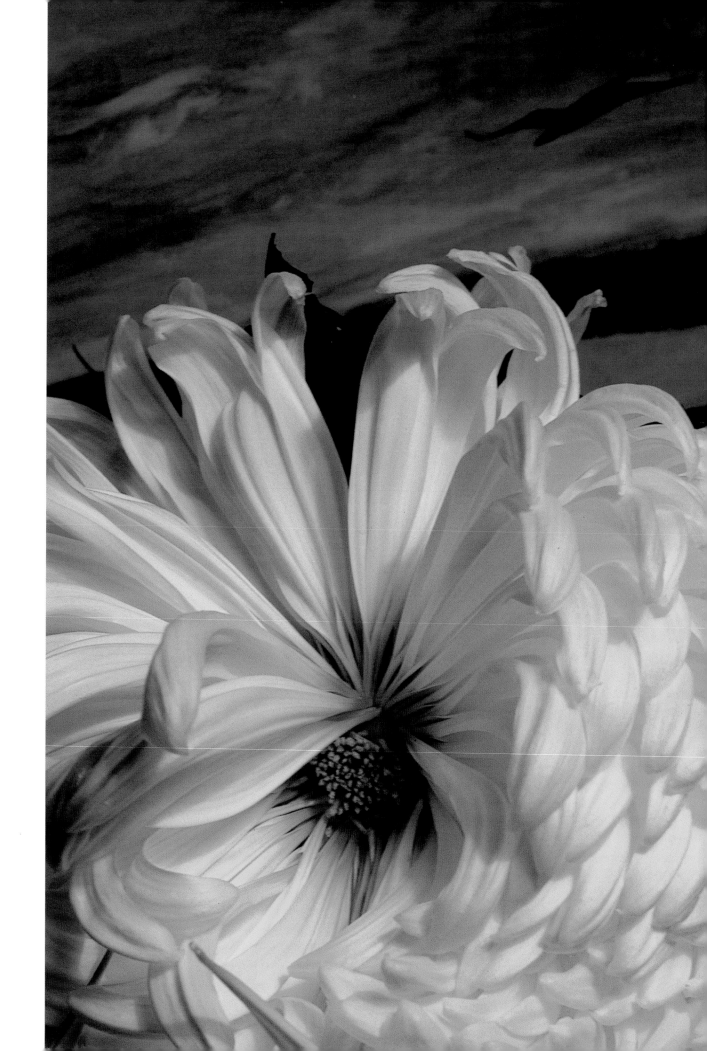

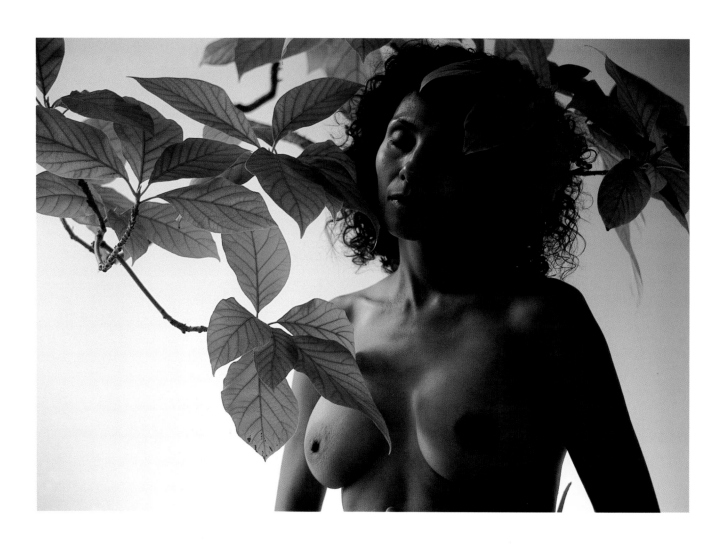

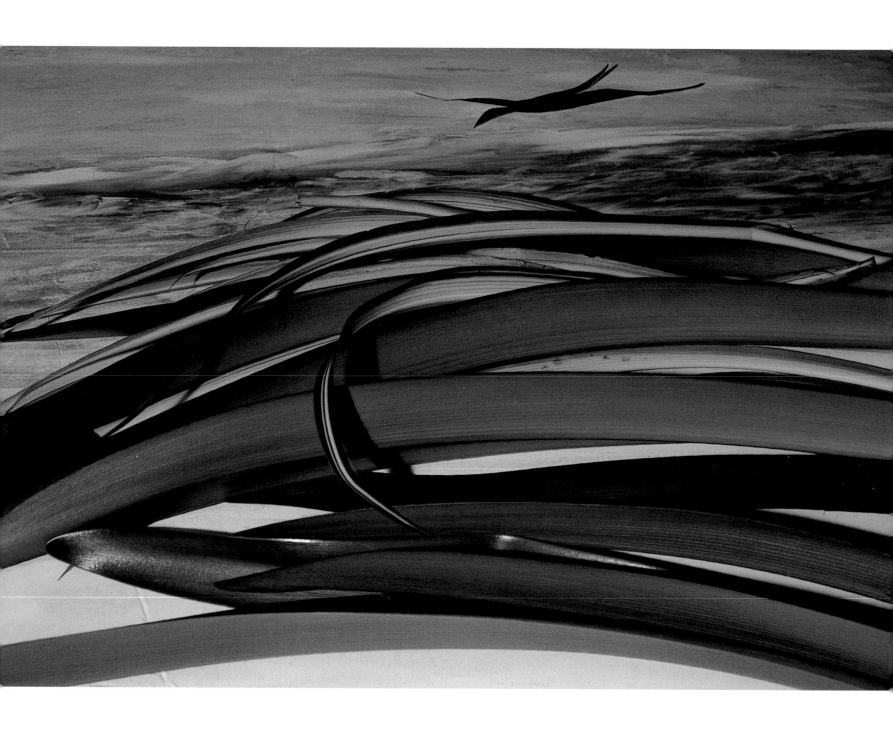

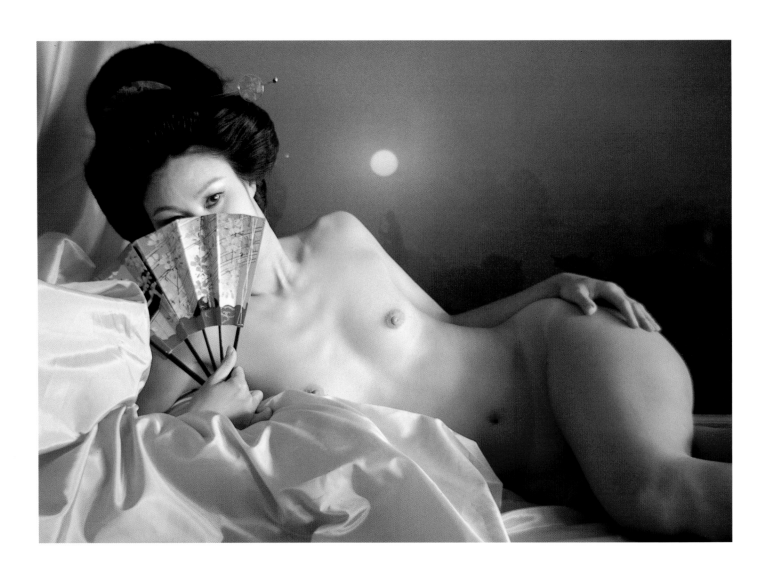

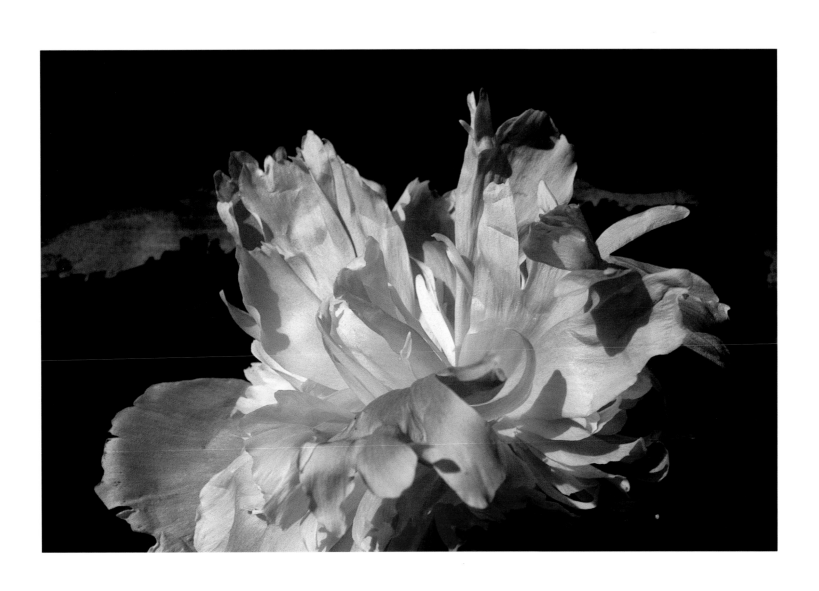

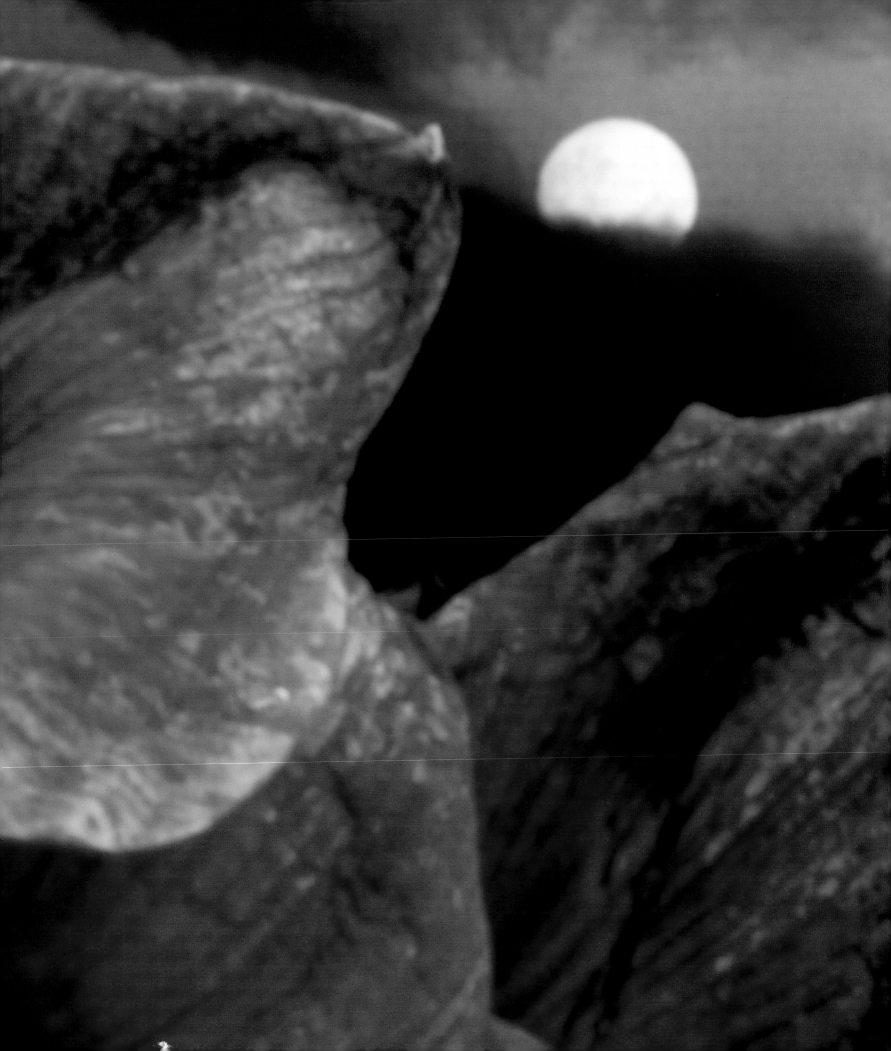

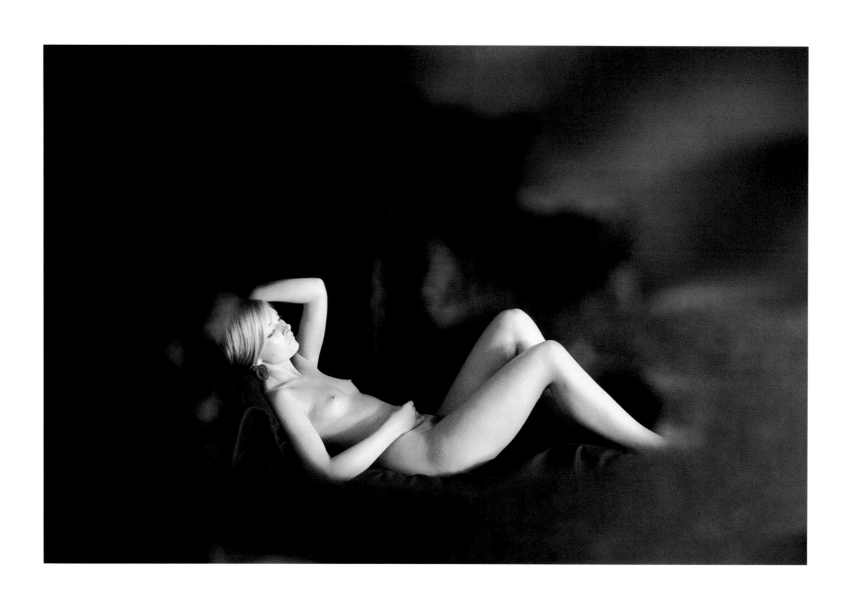

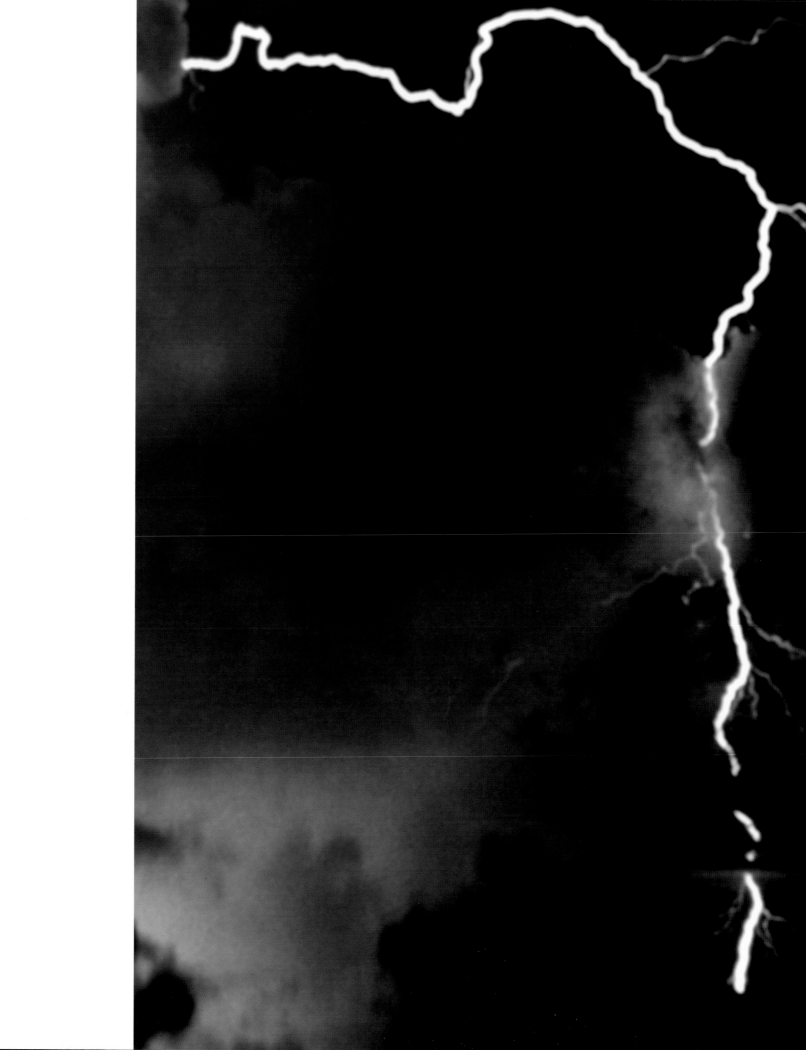

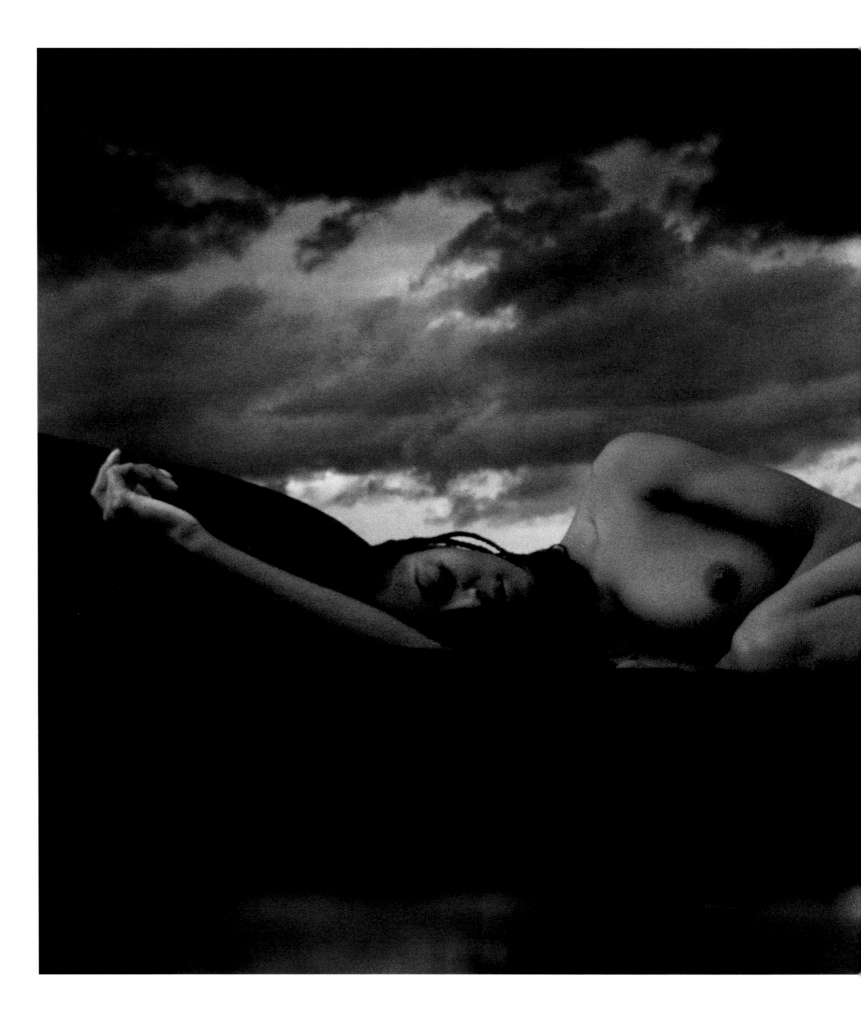

LONGING

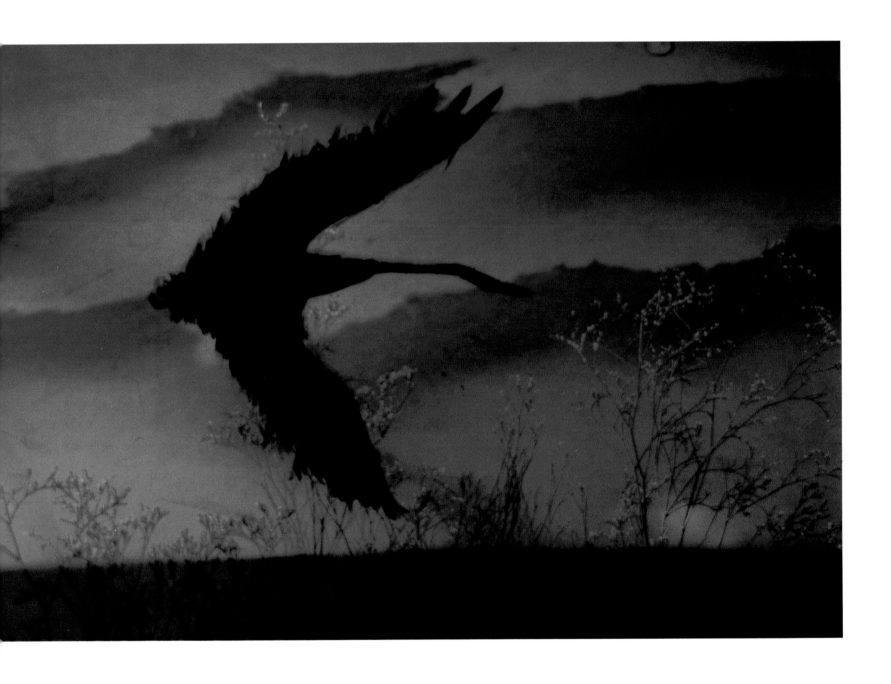

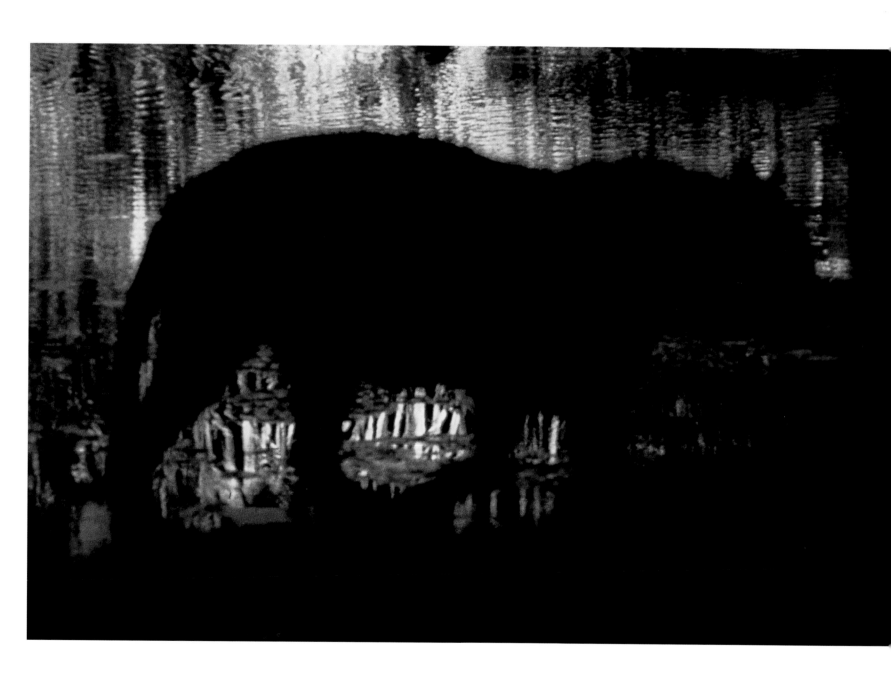

LAST NIGHT

During the disorder of a wheeling dream
your sighs broke through the confusion,
whetting it, befriending it, dizzying me
like the whirr of avenging bells.
Cautiously I glanced upward.
There, where a moonlit sky should have been,
was an angry sea.

Like a ghostly ship, your voice
plied the murderous waves.
Somewhere beneath their havoc
the moon and stars were hiding, raging
as the sea swallowed your sighing.

Perhaps I awakened to a warning.
Some dreams, going unrealized,
dance away nonchalantly.
But this one persists—
patiently breathing on the dawn.

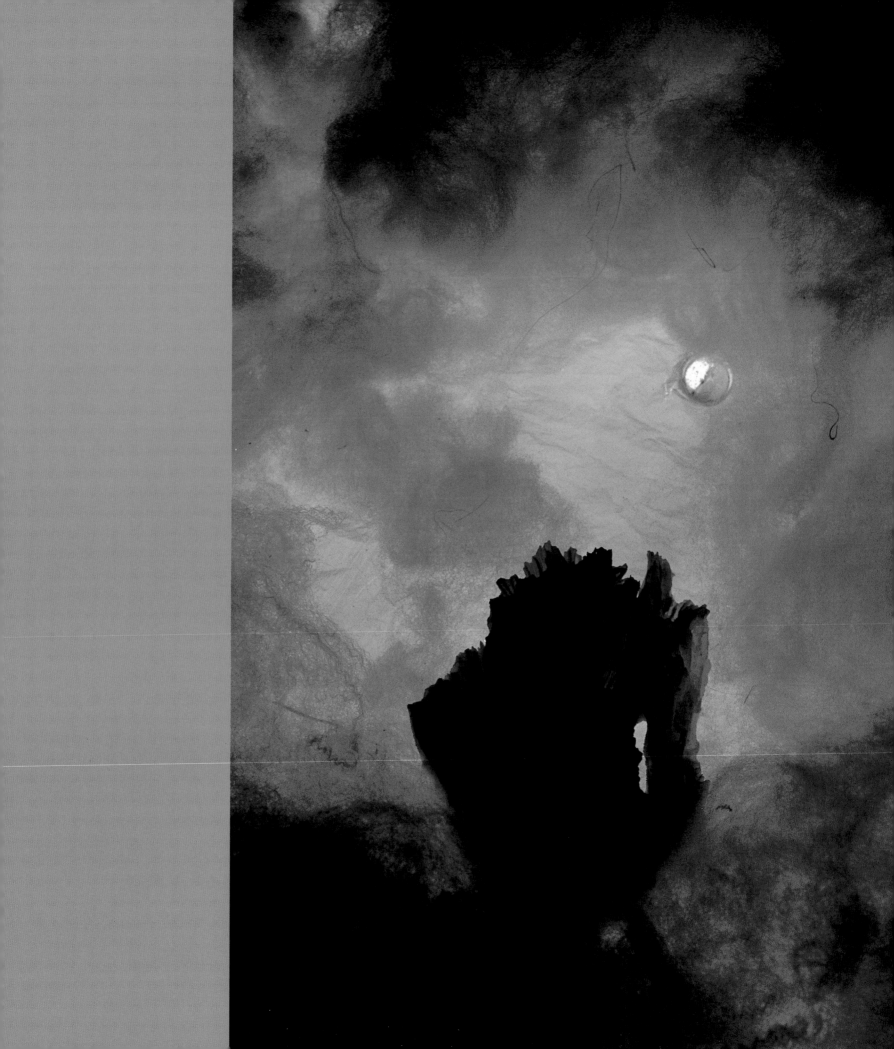

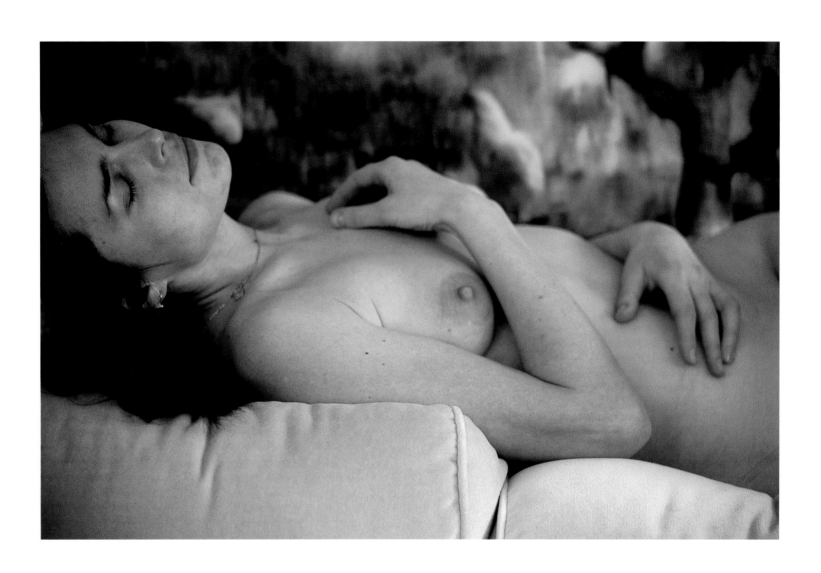

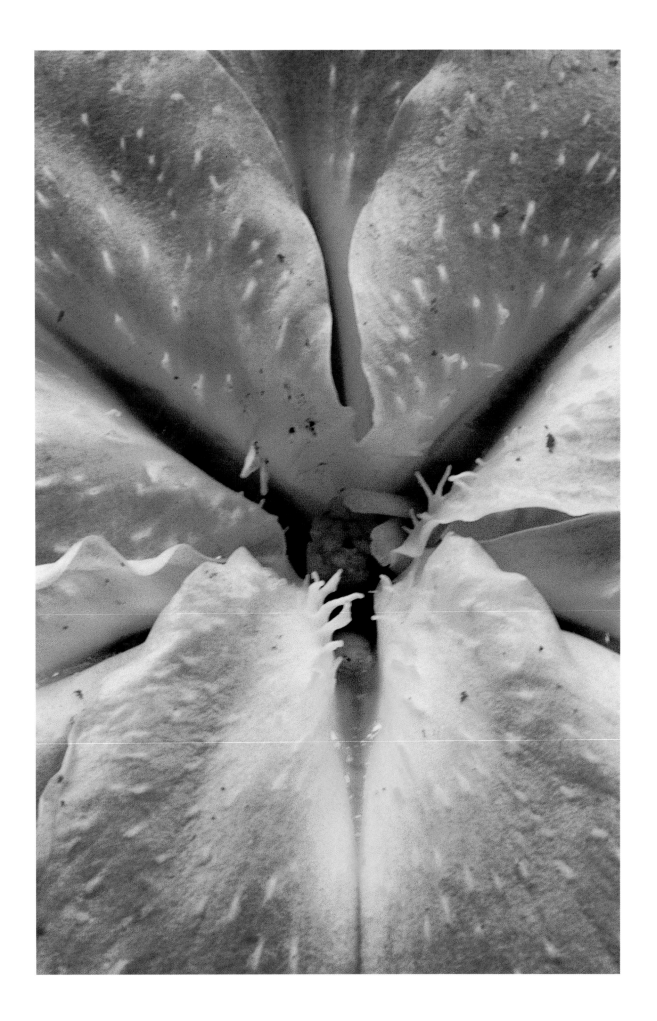

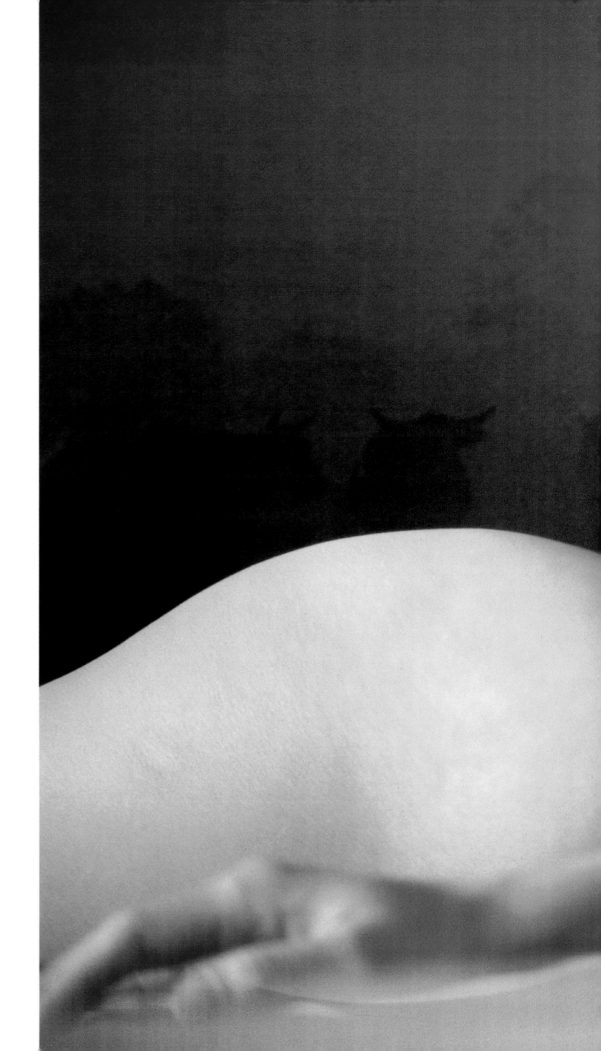

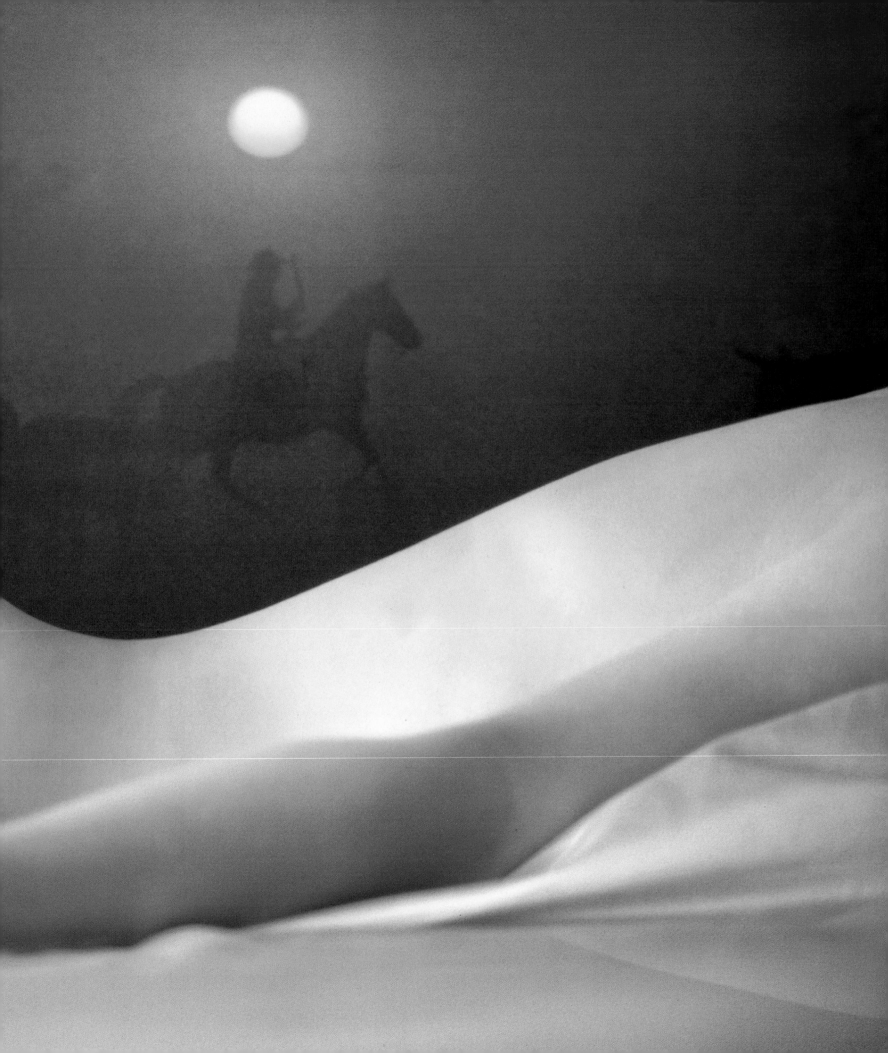

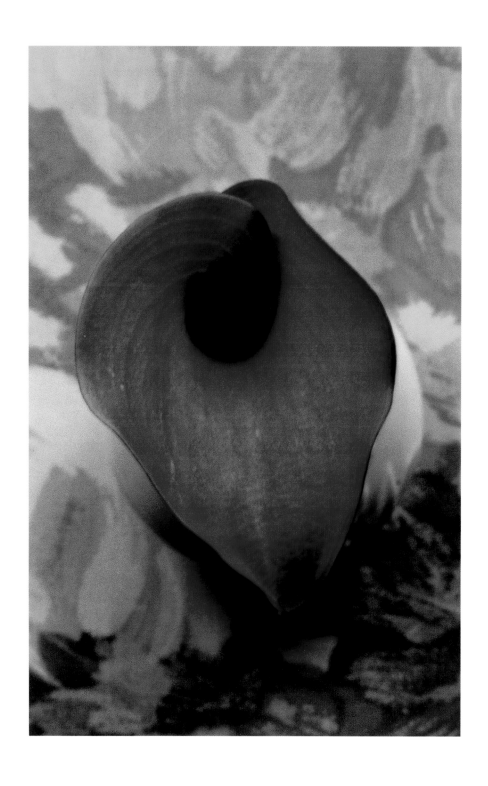

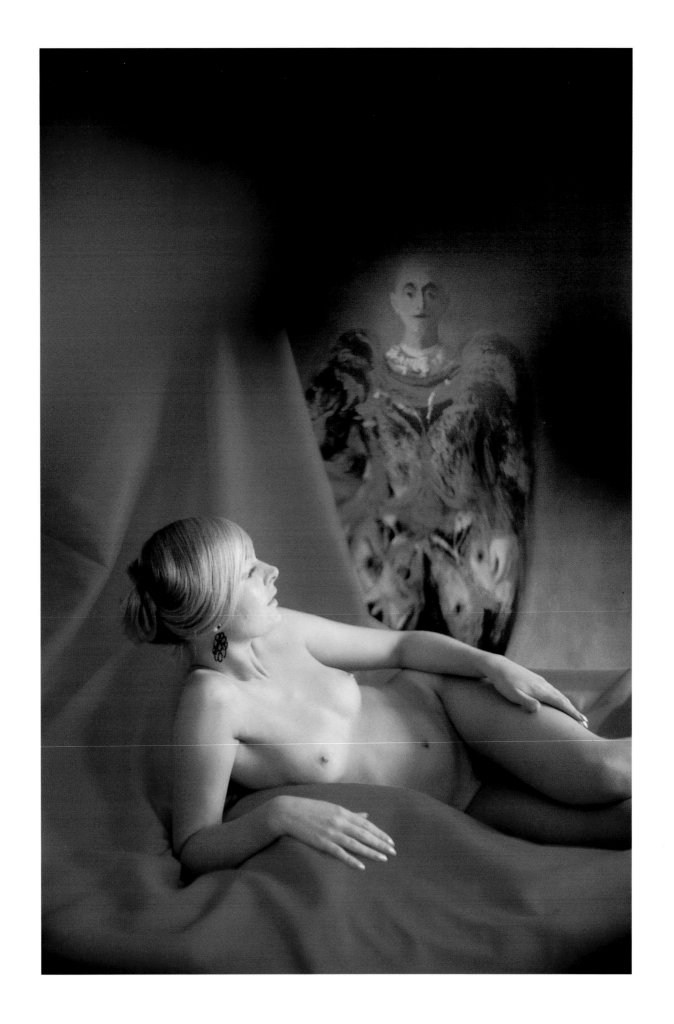

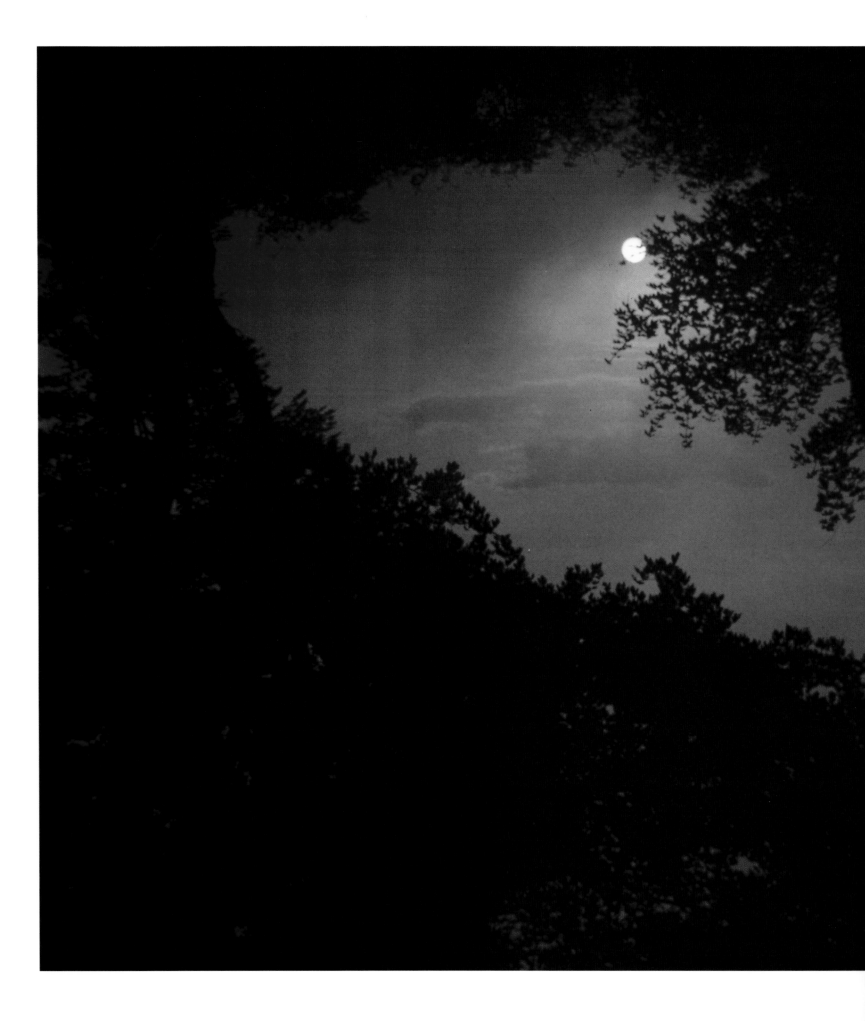

THOSE THINGS

A talk with myself
leaves me free of doubt.
I am helplessly afloat
in your sea of arduous moments—
when twilight waltzes through your eyes,
when your lips touch my lips,
when your passion bursts
so gently into mine.

Those things and countless others
make longing for you inexhaustible.
Drenched with such reigning love
I no longer search for its aura.
Huge petals of contentment
keep falling like blossoms
during a fathomless spring.

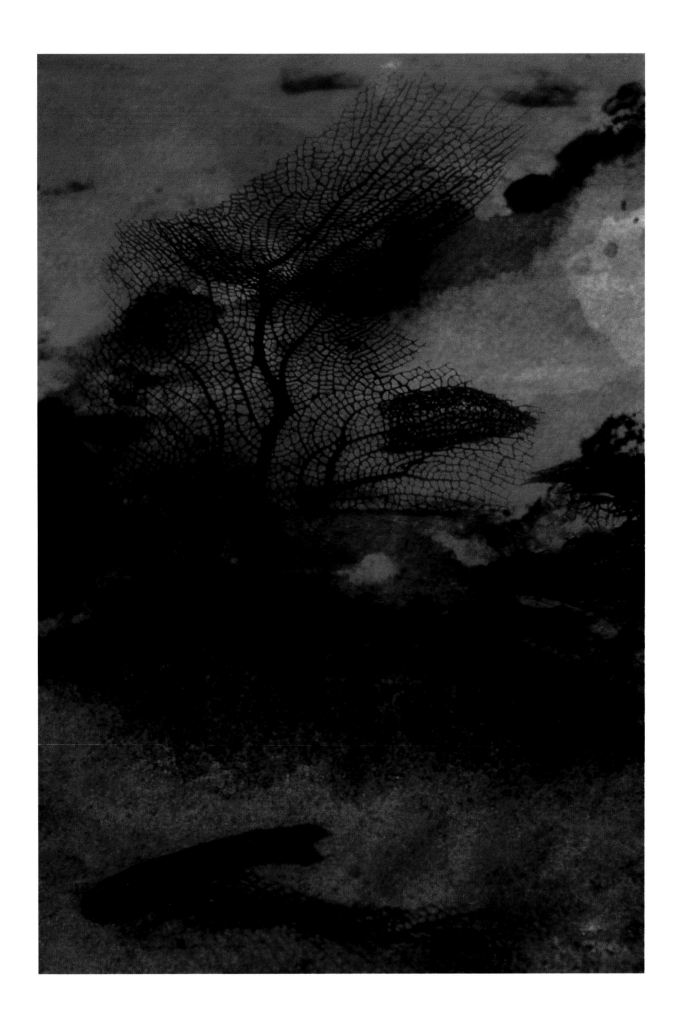

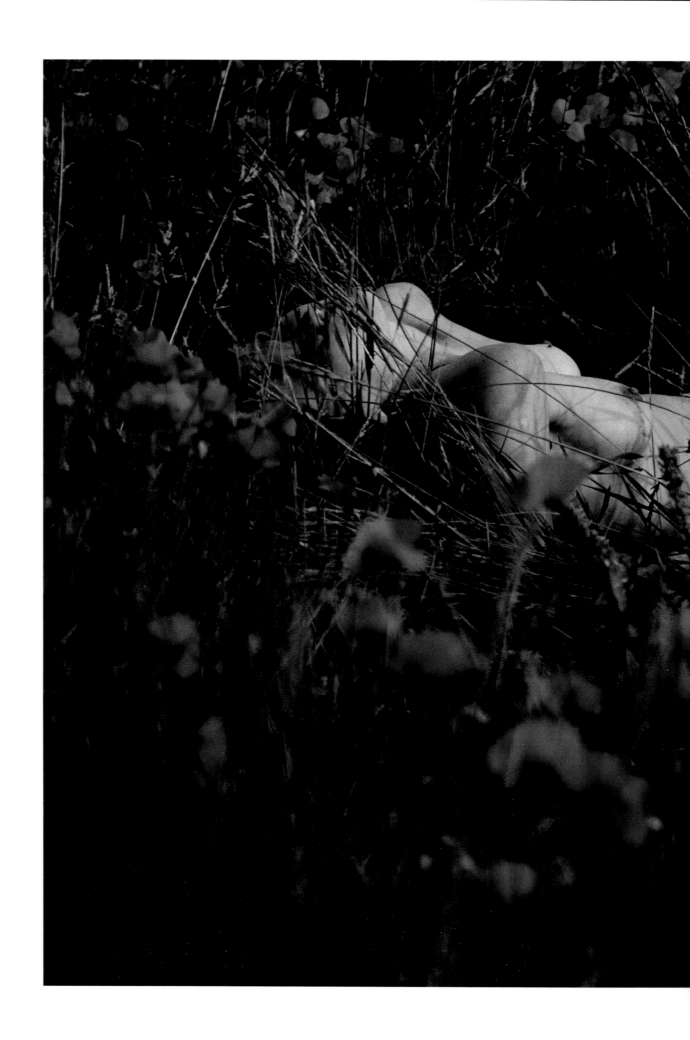

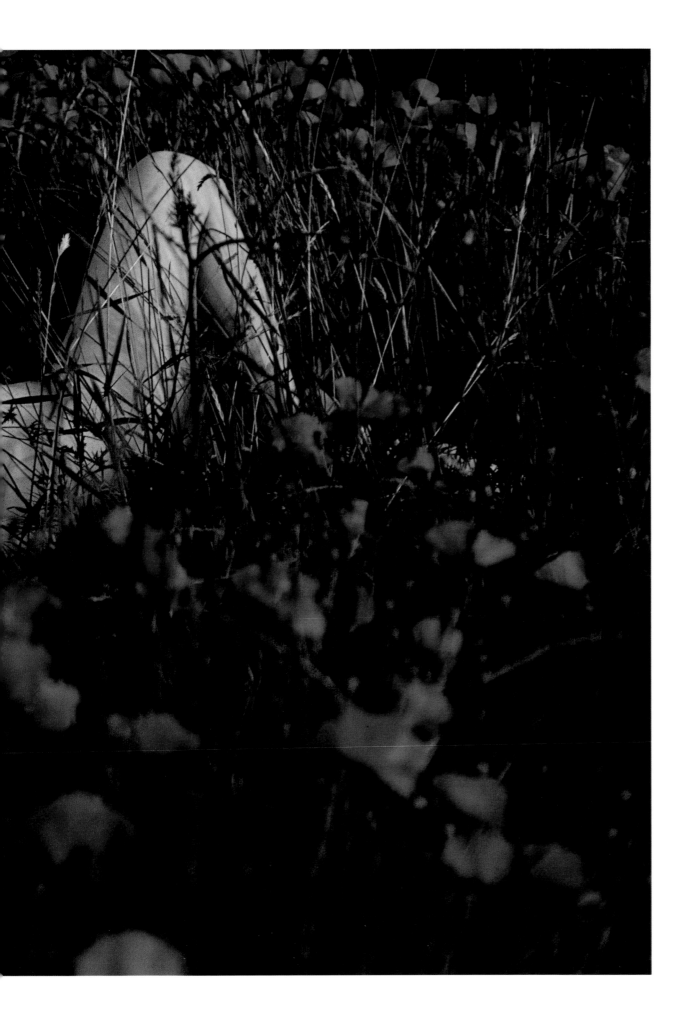

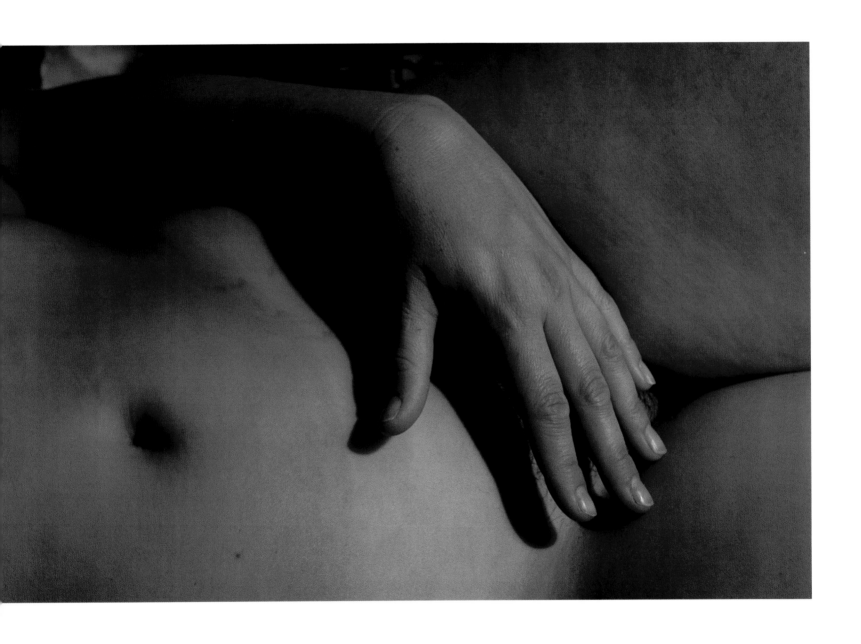

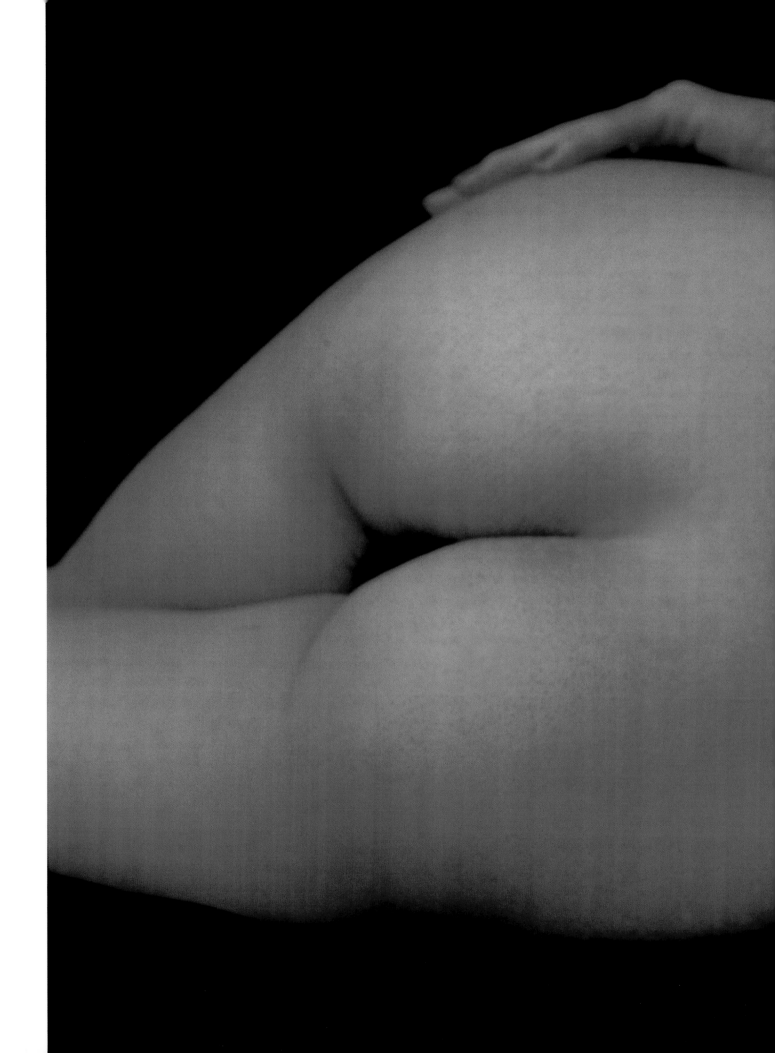

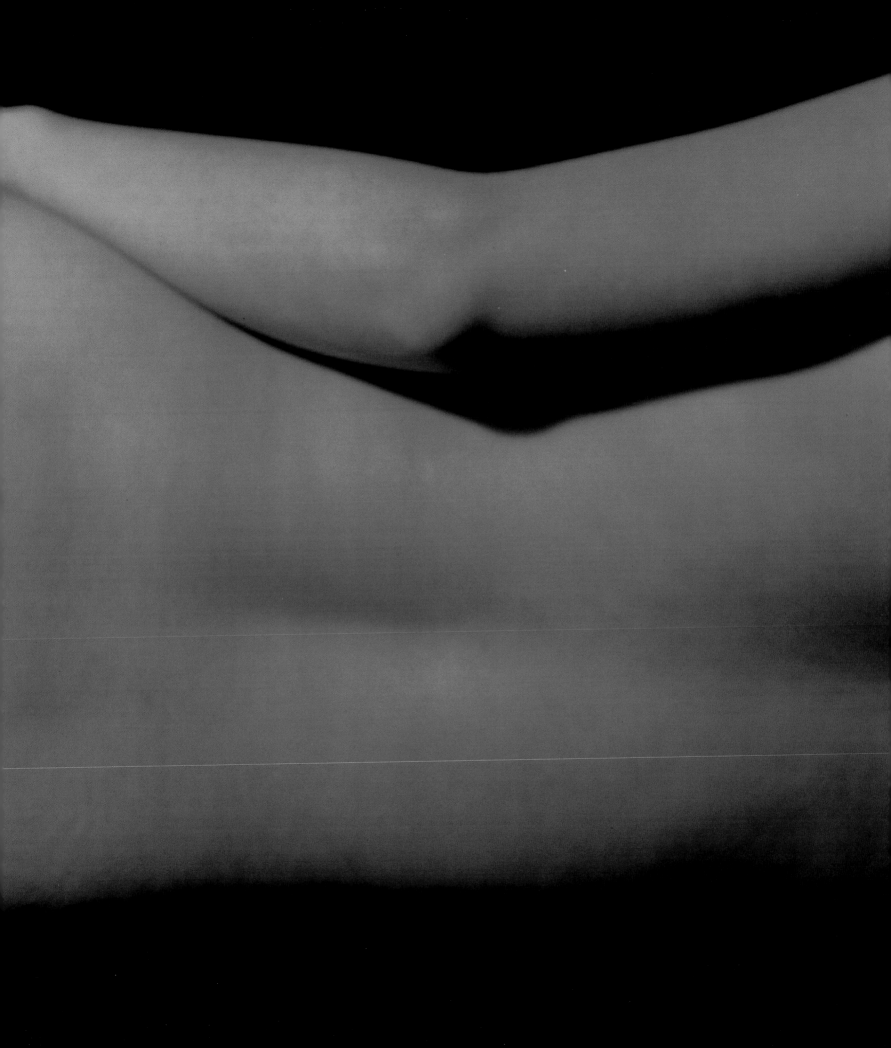

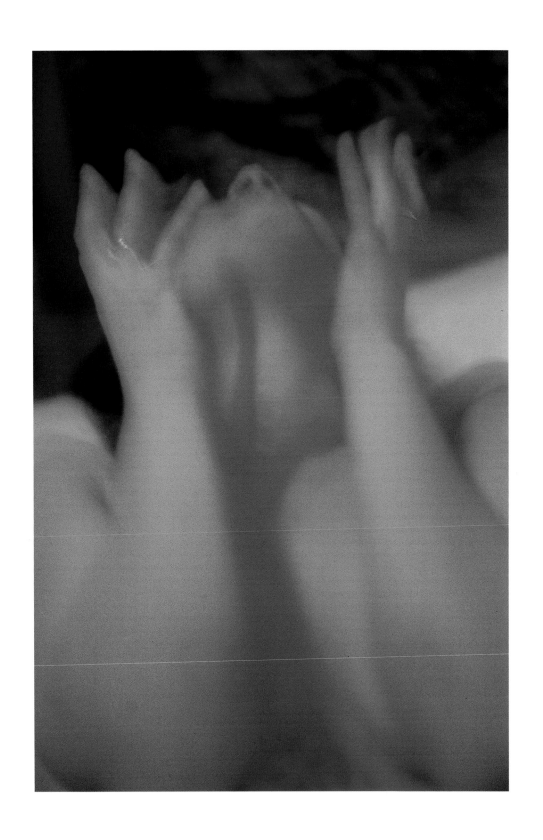

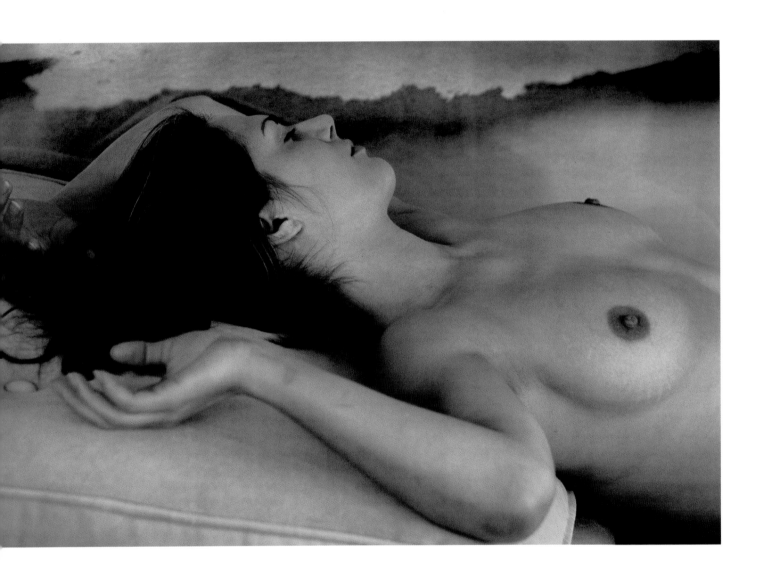

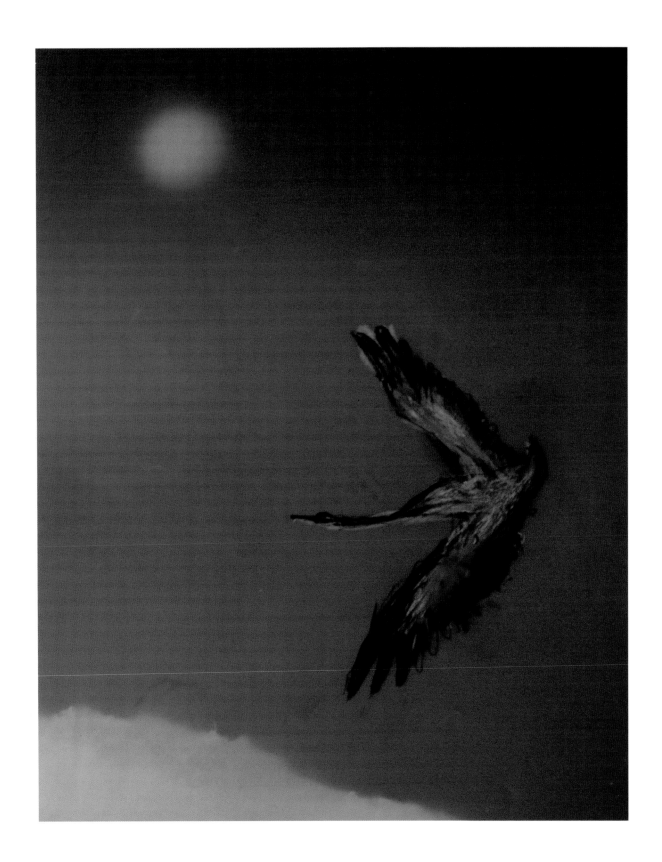

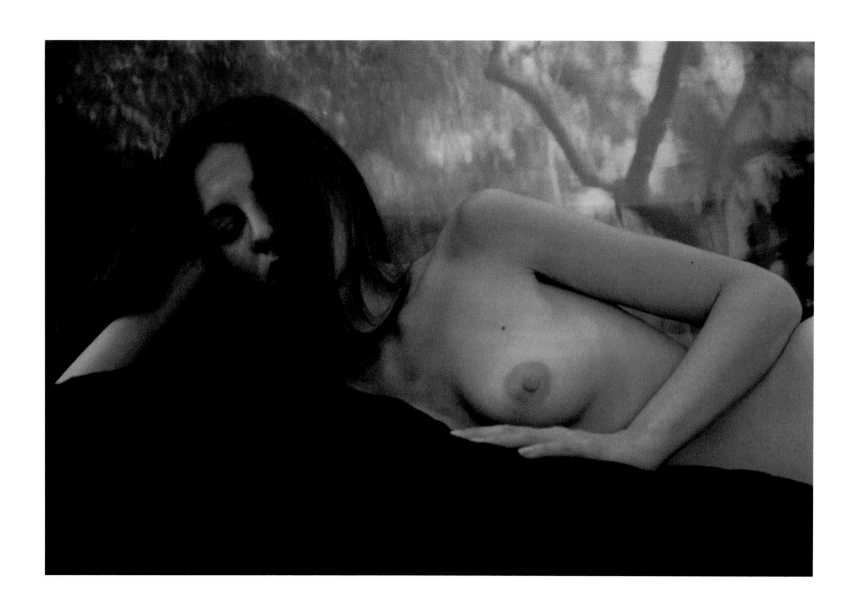

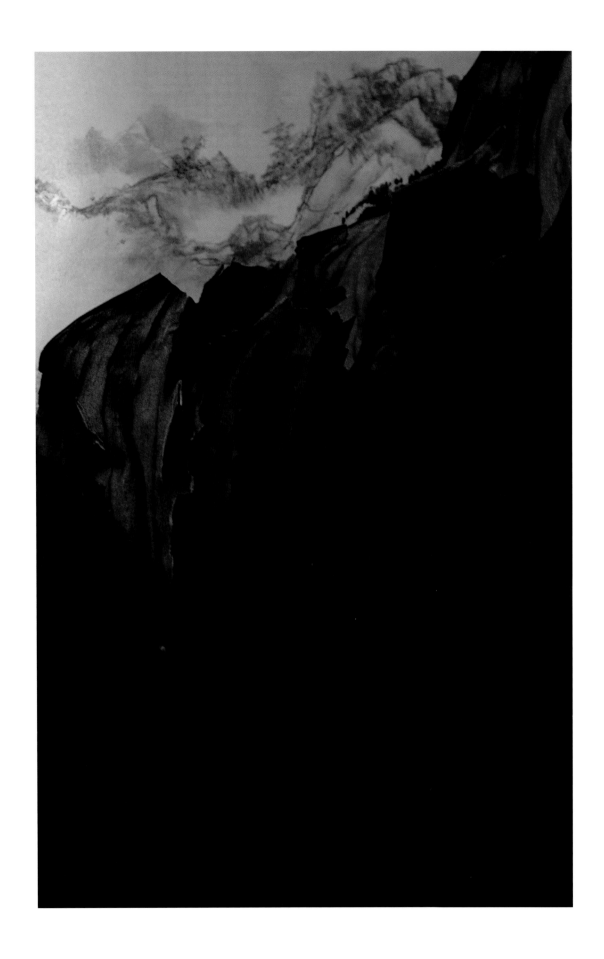

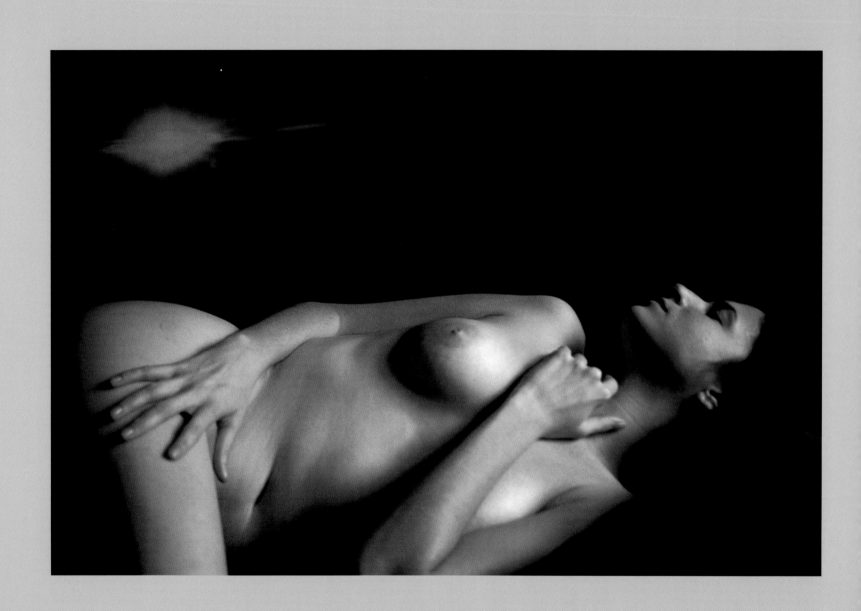

REMEMBERING

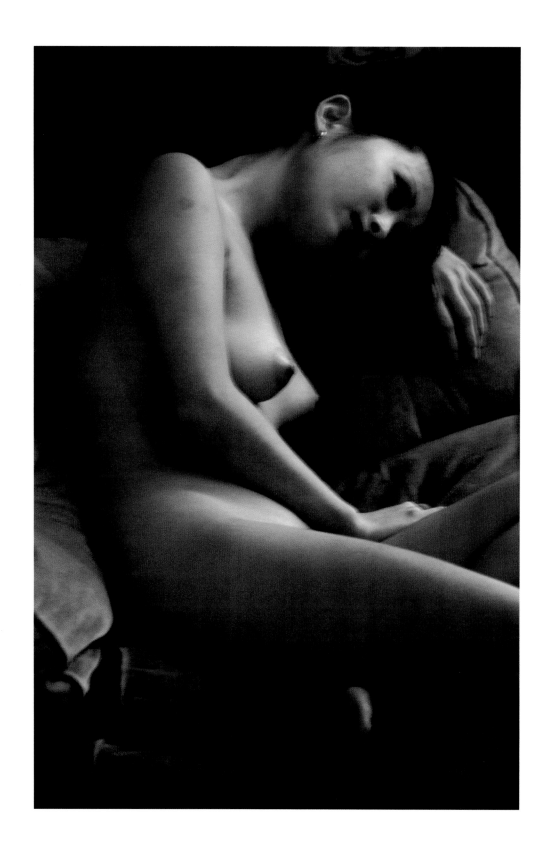

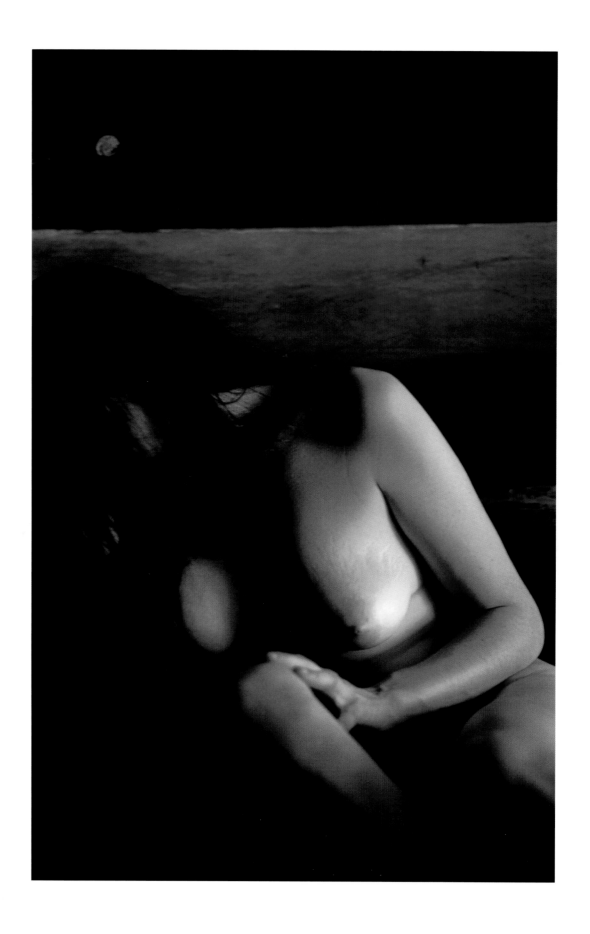

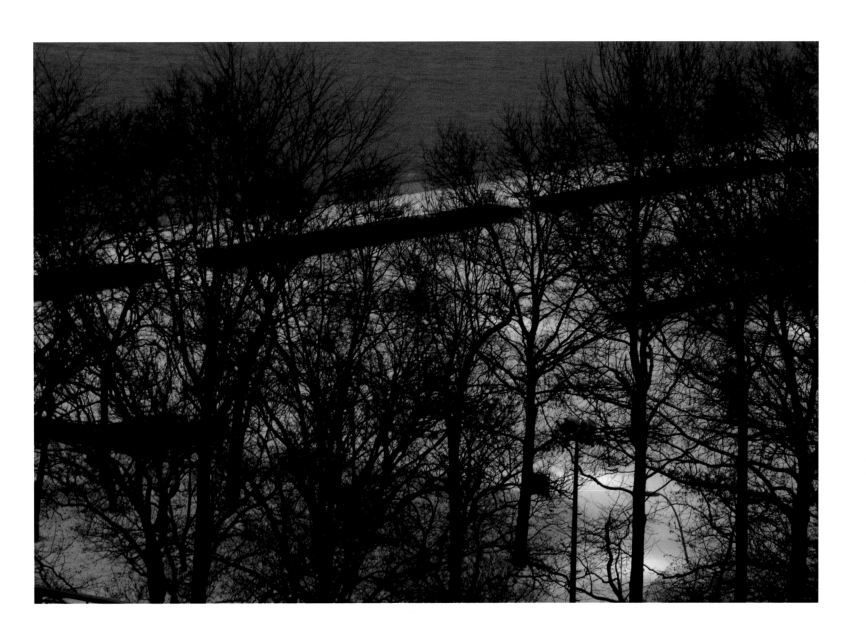

DAYSPRING

As we slept,

night slipped out

without a murmur.

Now, after awakening to another dawn,

I find your back frowning at me.

Memories bounce around the room,

escaping through the cracks

of windows and doors.

Your valleys and coves have grown cold.

I lie here abandoned,

longing for you to give

the thinnest hope to my heart.

 Speak to me.

Silence only deepens the wound.

With clouds of this dayspring hovering,

you seem to have forgotten

those moments neither

 you nor I

should allow ourselves to forget.

Surely some distant night may remember,

and accept them into our dreams again.

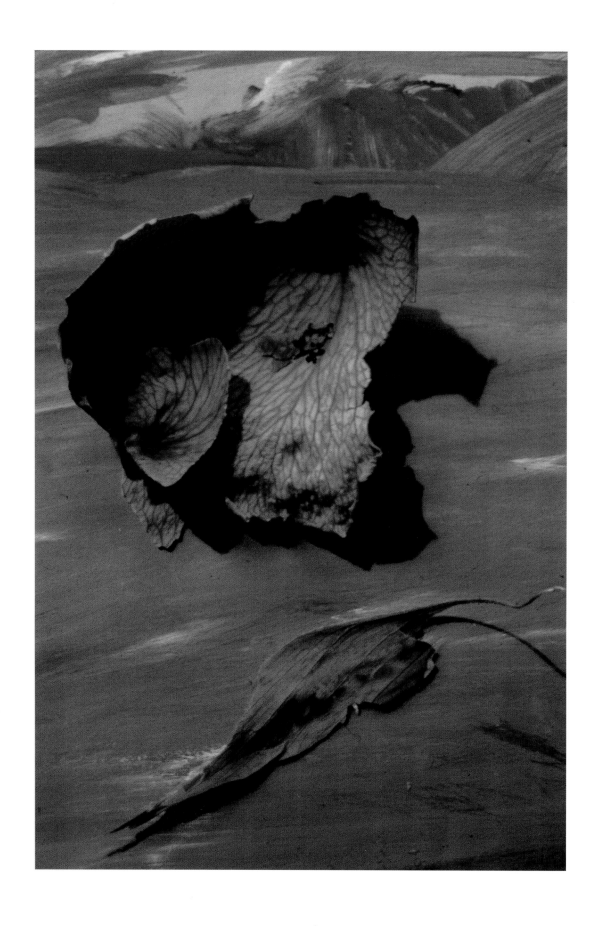

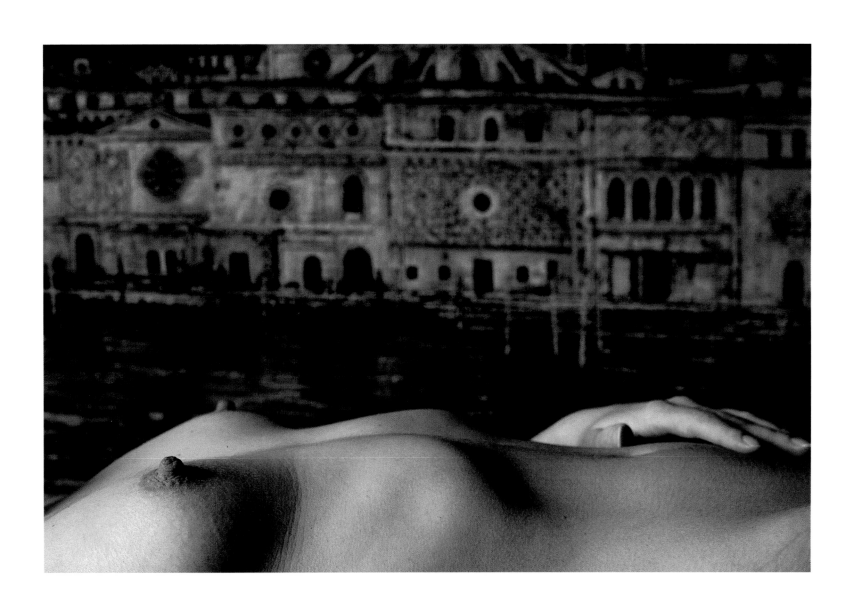

YOU LEFT ME DREAMING

My thoughts swirl with memories of you,
of sensuous afterthoughts refusing
to leave, day or night.
Breaking through the silence,
swarming like bees,
they feed the disquiet
that is swallowing me.

For years we clung to each other
like blossoms in moonlit dew.
But tonight the moon hides in the darkness,
and I lie restless beneath its blanket—
devoting myself to patience.
My love for you
is as measureless as air.

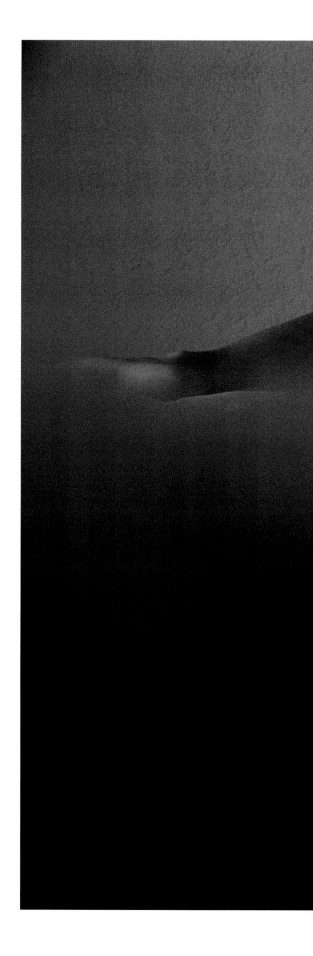

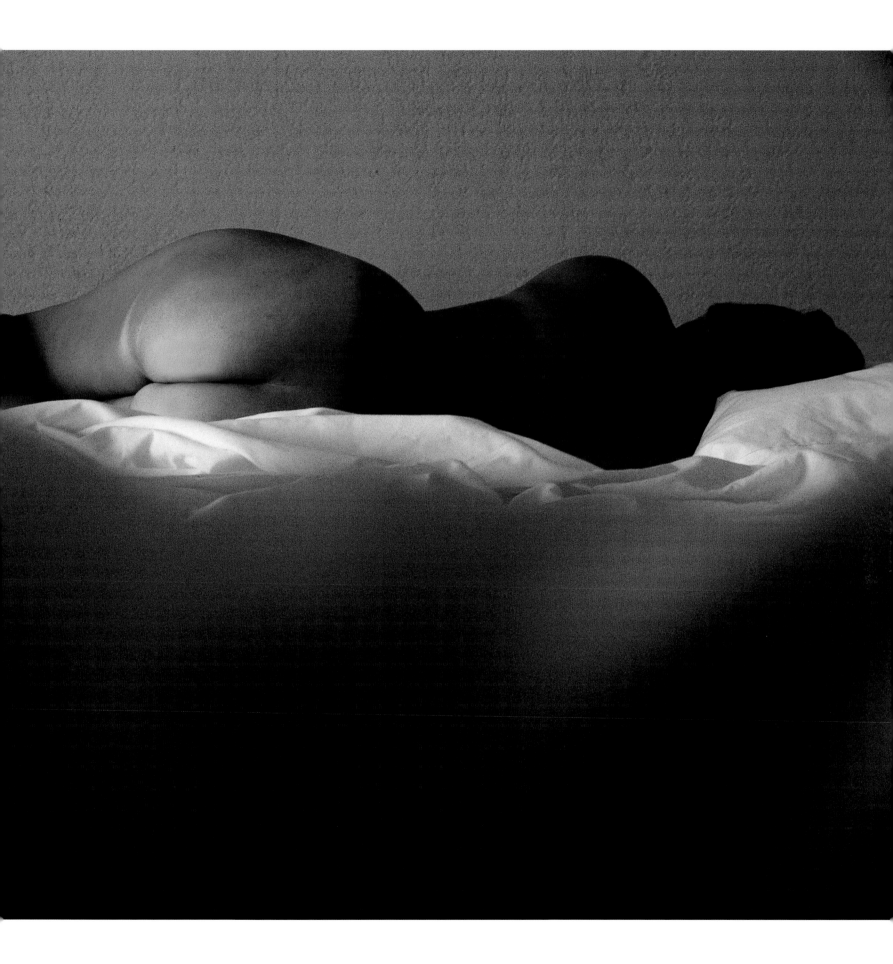

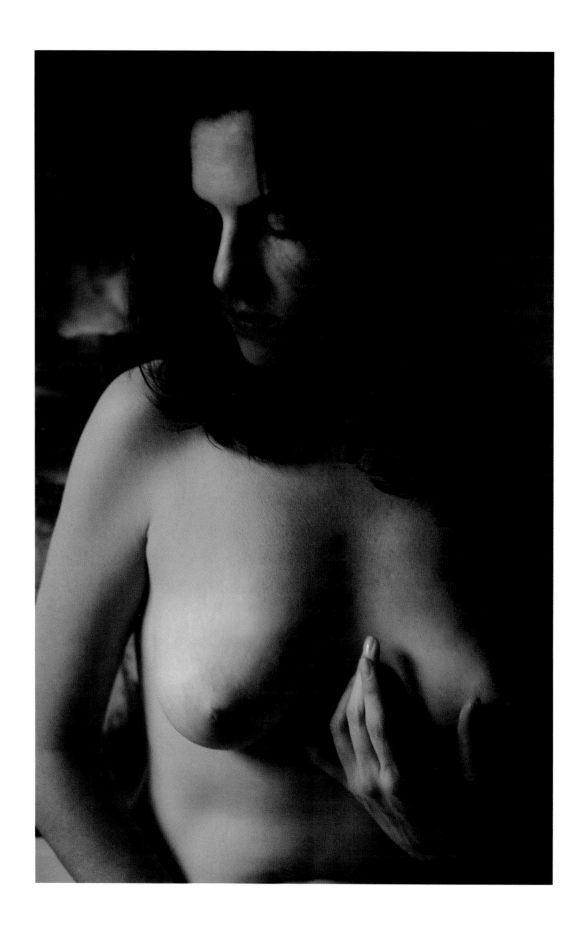

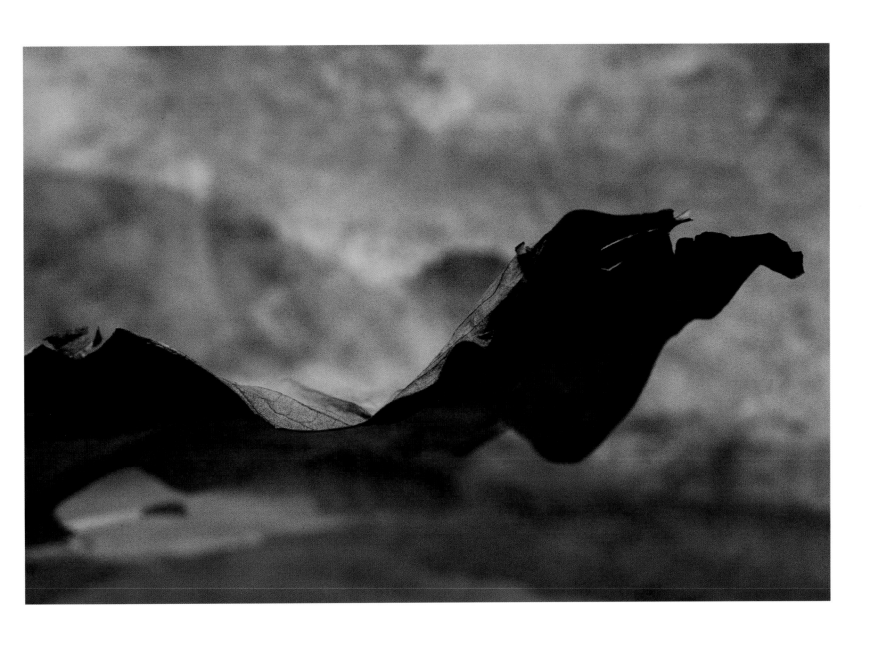

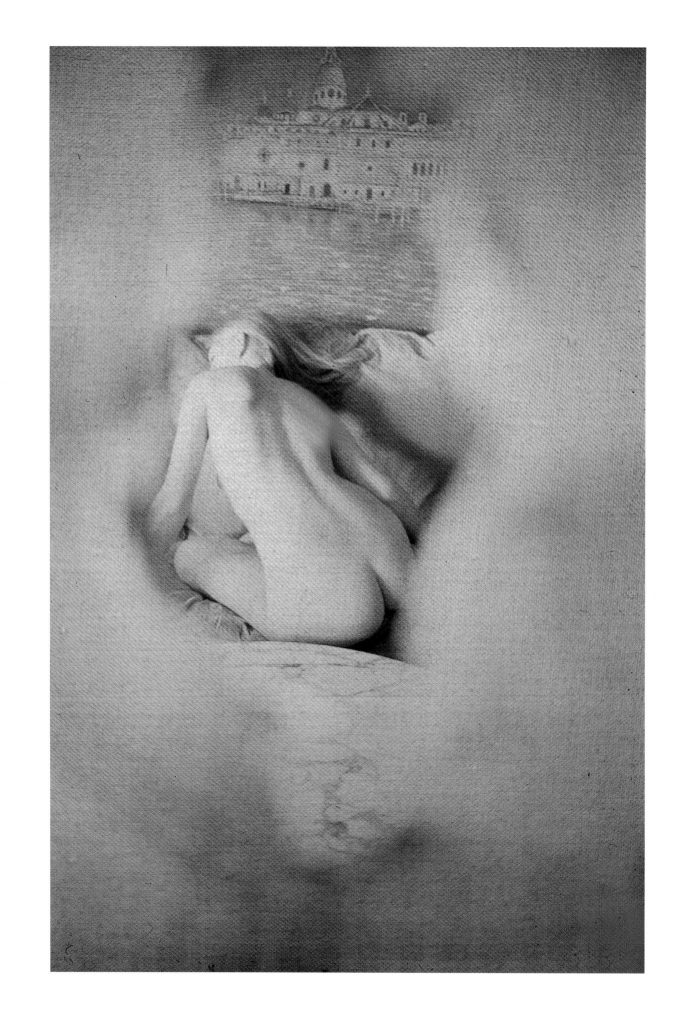

MEMORIES TO FORGET

You put on your Monday clothes,
then fled into the morning,
leaving the door ajar, the sky red,
and the clouds ominous.
Now, with only signs of your presence left,
I lie exhausted in the ashes
of shapeless memories.
What was once a rapturous oneness
smolders in the charred dreams.
I gaze at the floor, walls, and ceiling
and recall the sweet plunge of my flesh
 into your flesh,
the murmurings, the cries of lustful singing.

Another morning is coming,
rolling in the invisible air—
ominously swimming the fog
of another frosty tomorrow.
I must return to myself
and allow those memories
to roar with silence.
Passion has suddenly flown away
on coal-black wings.

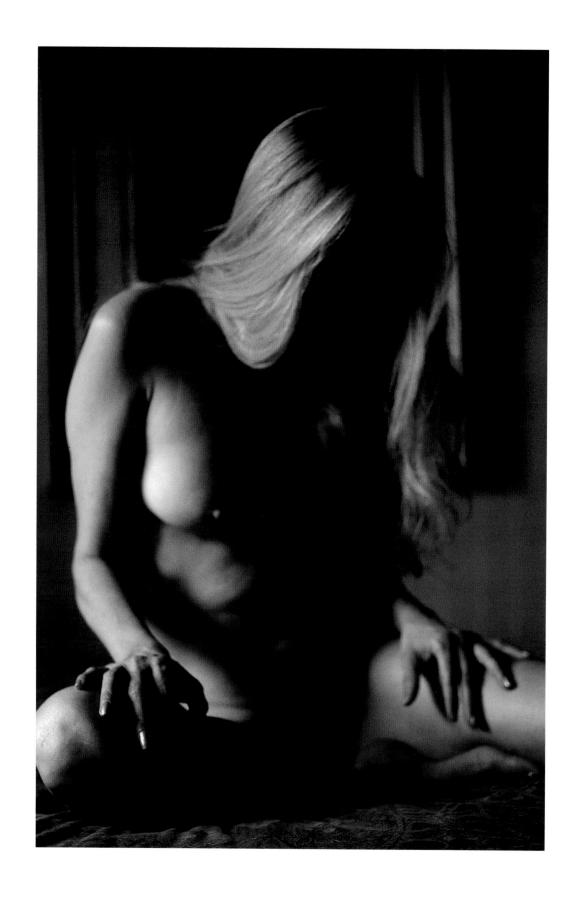

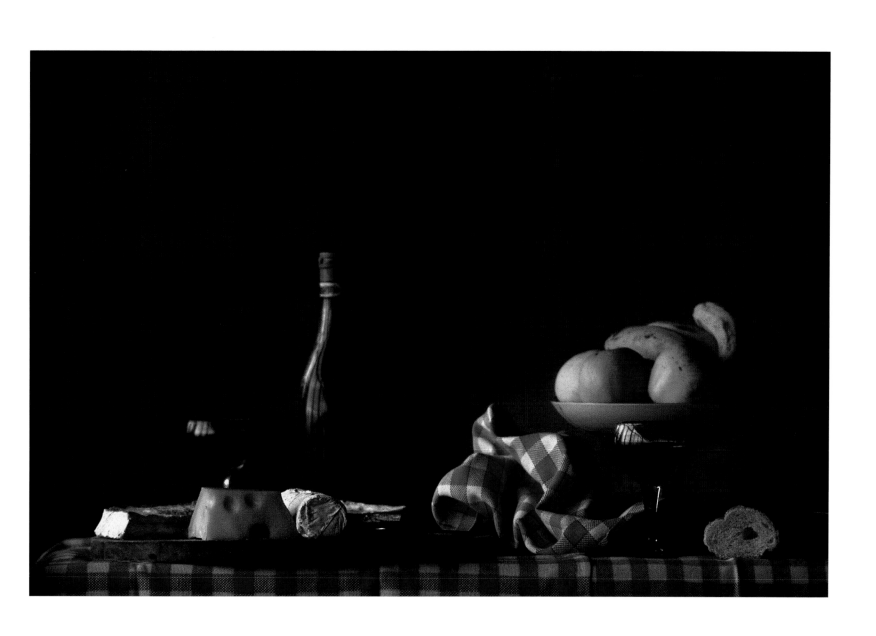

WAITING

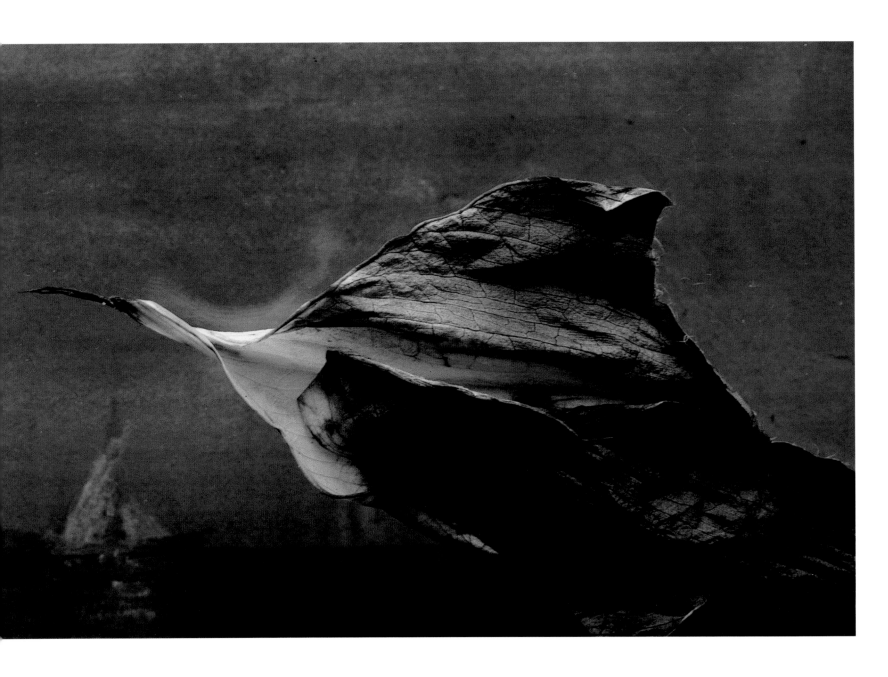

I'M NOT ALONE

I saw you today

through a haze of faceless heads

attending their lunchtime deals.

My heart outpounded the jackhammer

attacking the street outside the window.

Who was the beast breaking bread with you,

and with such vulgar eyes, burning?

How could you let him caress hands

I held just one love ago?

When fleetingly you glanced my way

and touched your wine to his,

I surrendered to sanity.

Whose bread or wine you share

is no longer a concern of mine.

Loneliness is still hanging around.

The stars are still breaking

and falling like tears.

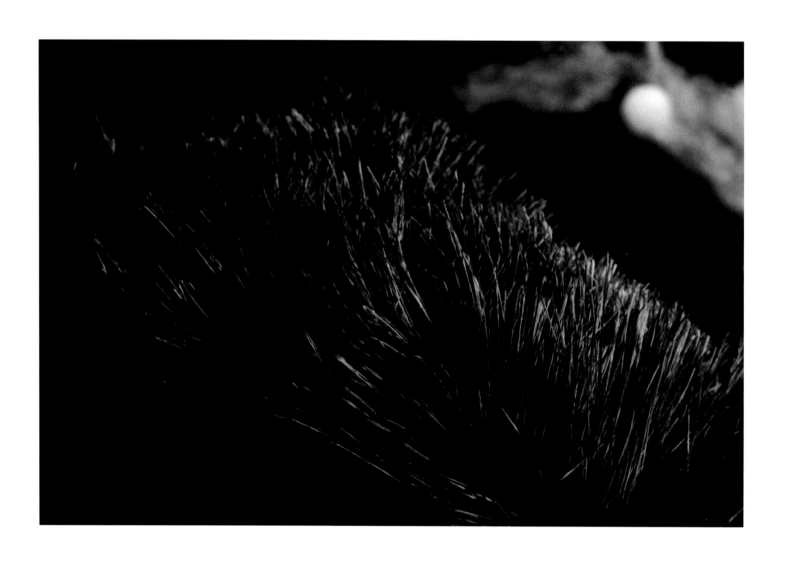

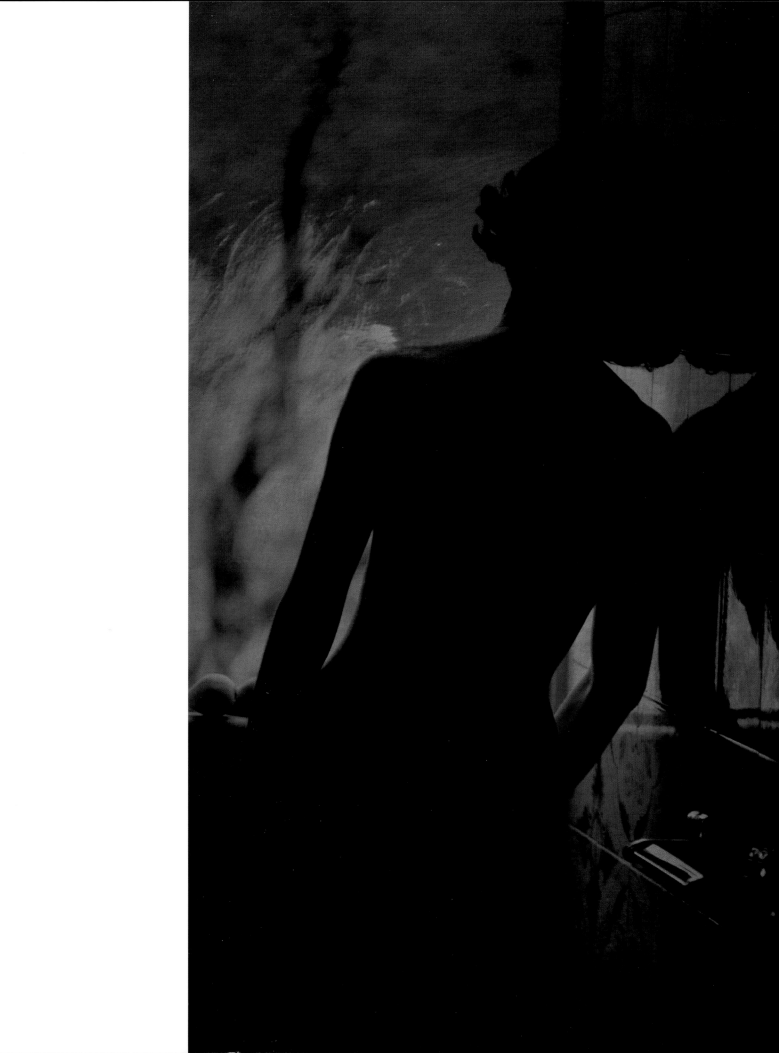

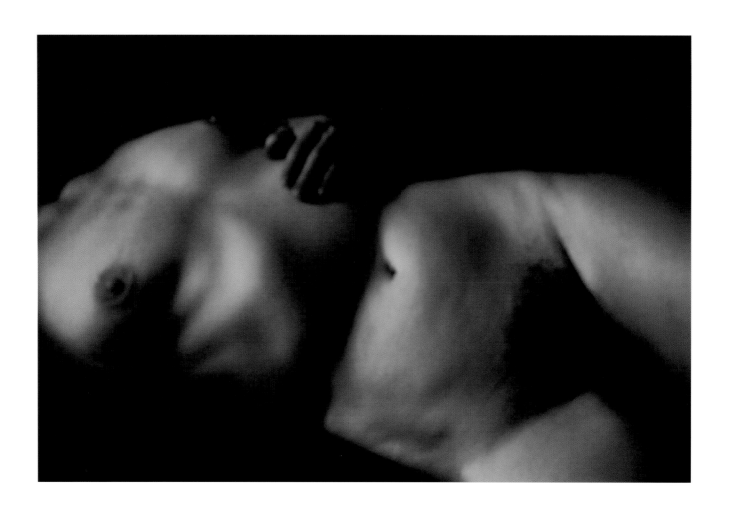

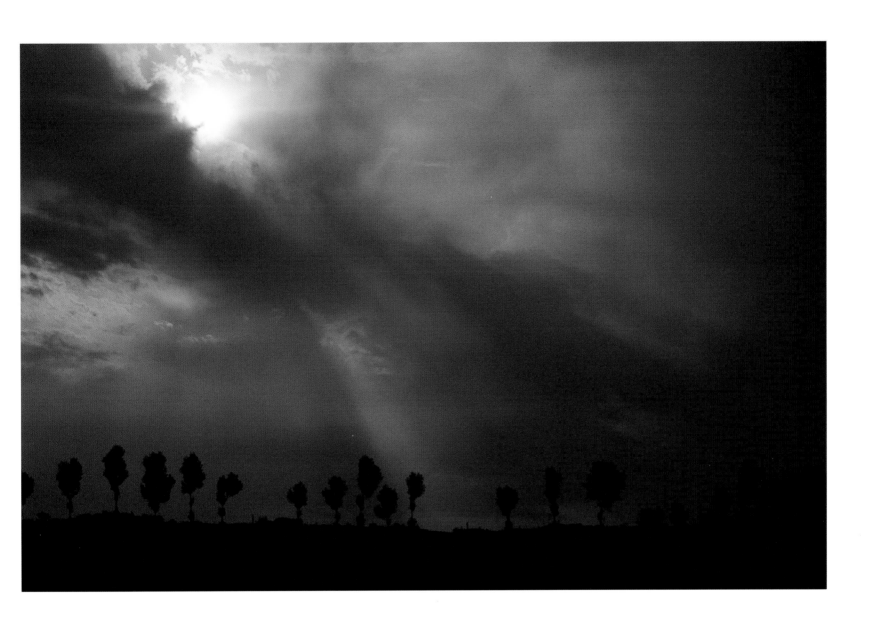

I BREATHE DEEPLY AND WAIT

You and longing are as one.
Before sleeping or after waking,
I keep remembering your orange laughter,
the curling of your softness touching
my lips with the fragrance of dew.
How many years lie between your absence
and these lovethirsty days?
Your return would come bursting
like light of a golden dawn.
At times our togetherness
seemed so involving,
even somewhat mystifying.
Yet, with each day's passing,
the memories of those captive hours
keep flowering inside me.
So, while you quietly wander,
I breathe deeply and wait.

Dawn breaks. You are still here,
still pervading the solitude.
 And I pay dearly
for your untouchable presence.
The moon and stars hold their secrecy,
seeming no longer to know you,
nor the one who loves you.

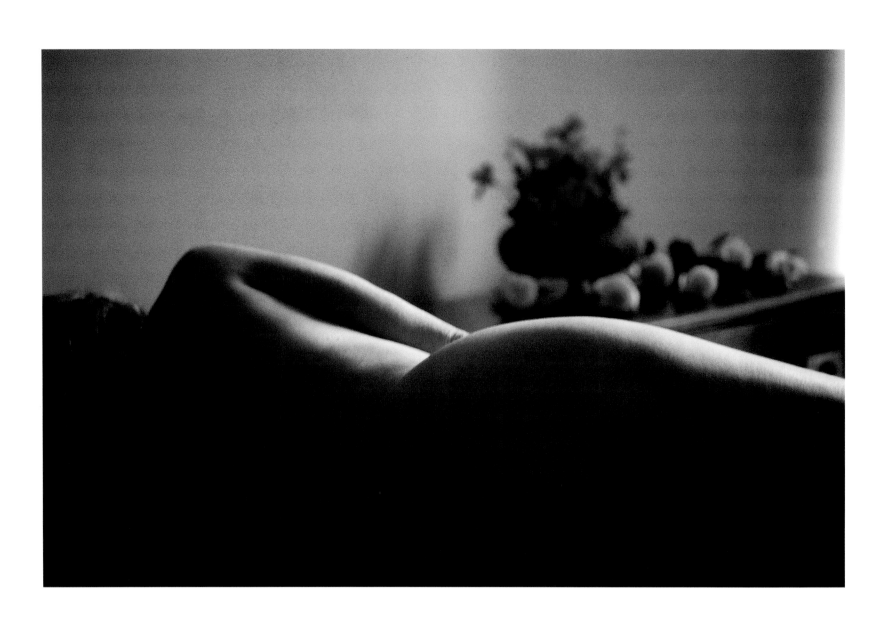

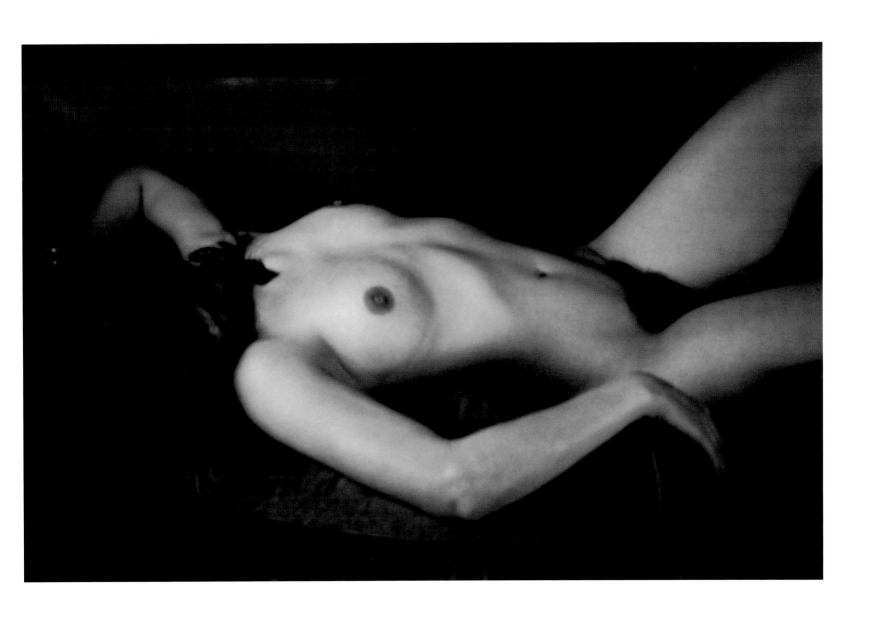

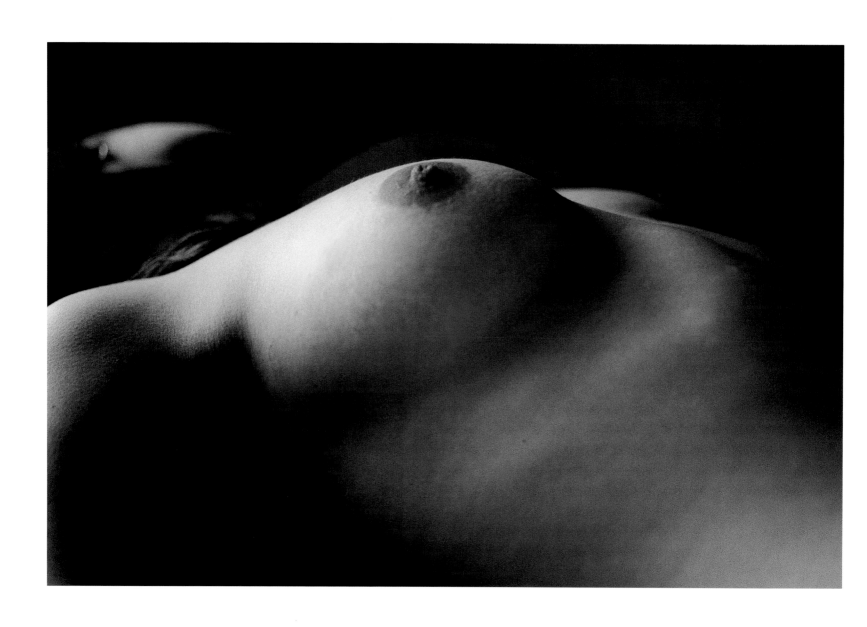

I KNOW

Nothing

can

be

more

indiscreet, or arduous,

than love.

Going, coming, or rushing to nowhere,

it

can

smile

while wedding two hearts,

and laugh

while scissoring them apart.

Having

no

truck

with

patience,

it can,

without malice or forethought,

bloom with honey, then stinging like a wasp,

change clothes in a hurry —

and plunge into oblivion.

I know. Take my word for it.

FRIENDLY ADVICE

Now and then,
during these unclear moments,
I wander back with regret
to this love—lost, wondering
why time grew weary of my bliss.
One friend, an unswayable poet,
scoffs at my regrets.
To his way of thinking, to bestow love
 upon one woman
is to covet the shade of a fickle tree
that for some reason sheds its foliage
during the heat of a disgruntled summer.

Perhaps his words are worth pondering.
Yet I still know
what I am in search of—
one unending love that claims
the need to be remembered.

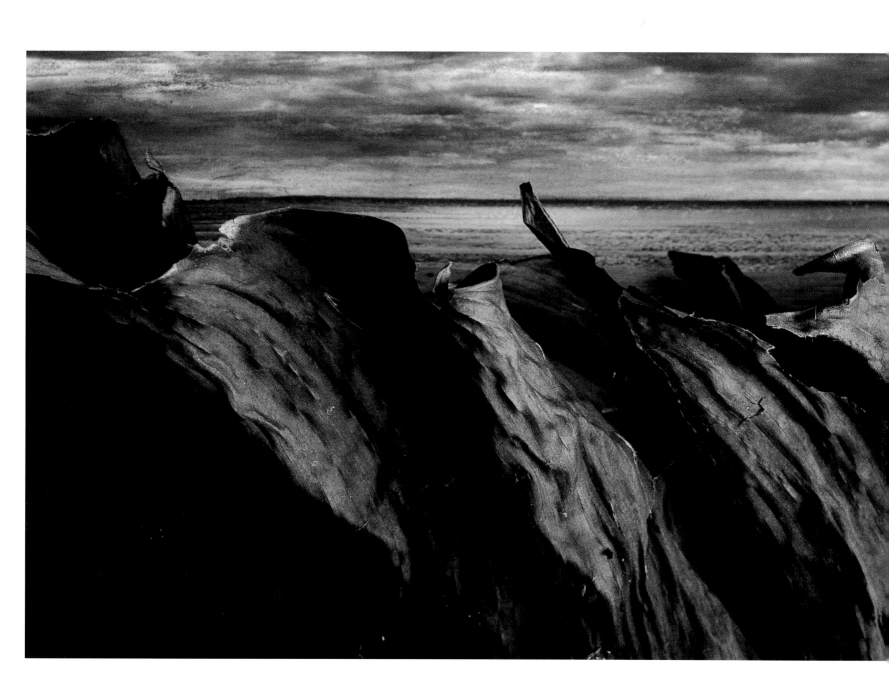

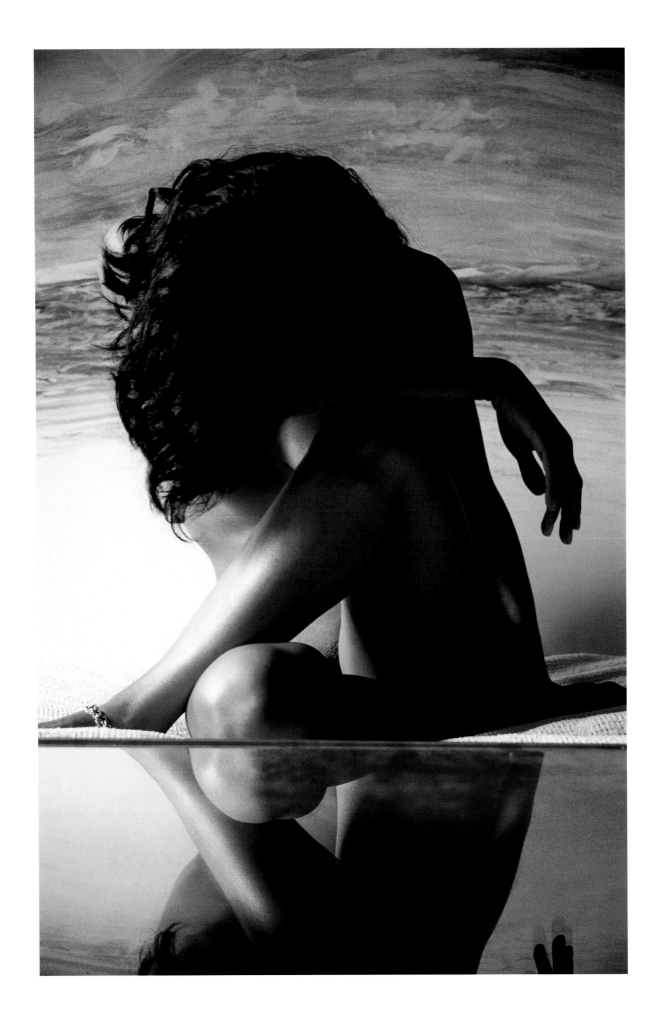

INVASION

Why, after leaving me alone with the past,

is your face suddenly disrupting my solitude?

I question its invisible presence.

Did it return to smile,

or perhaps frown, at a heart

that unraveled with your absence?

Loneliness razors into each sunup, every sunset,

and, like a pitiless sword,

refuses to make peace

with its victim—my heart.

Only remnants of a perished summer remain.

It seems unwise to linger in some place

where I no longer expect myself to arrive.

I have not sheltered my thoughts

from the pain of your leaving.

It burns like acid inside me.

After a wistful talk with your face,

I'm asking it to go back

until, heartfirst, it can return

to where I wait—alone.

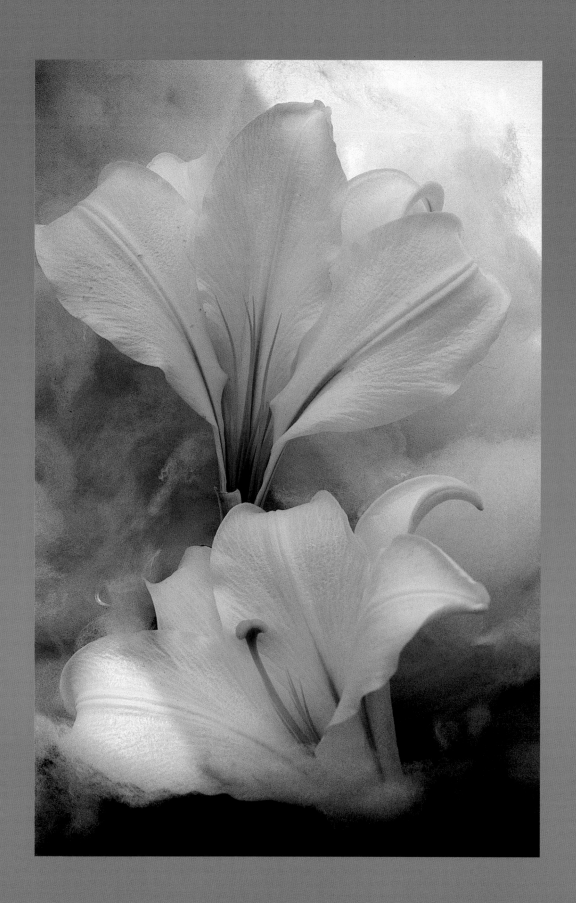

RETURNING

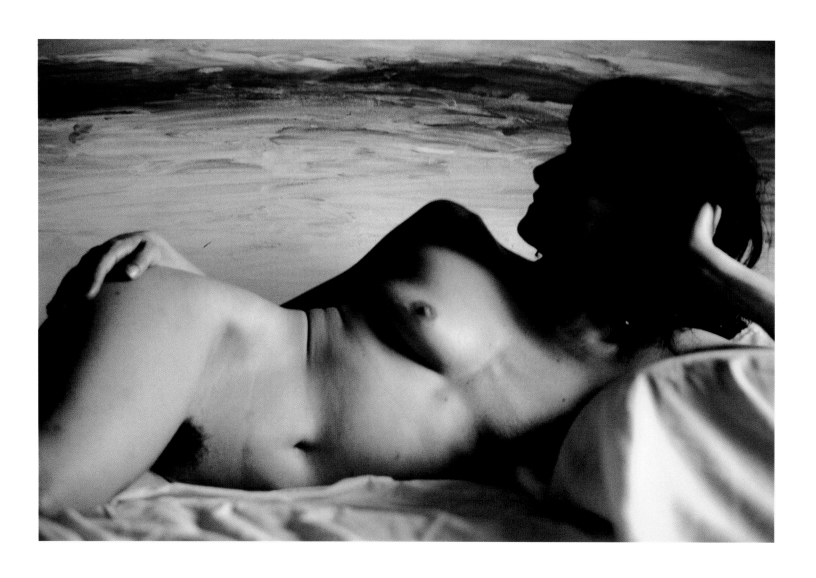

THE GREENING LIGHT

Suddenly the air is thick with joy.
Your roses entered my numberless door
and filled the deserted space.
Like a wave of blessing,
your message that traveled with them
sang with the glow of twilight.

So at last you are returning.
Of all that I've wanted to hear,
this is what I wanted most to hear—
from your own heart, from your own lips.
After so many faithless days
let us escape from the layers of stone
and bask again in the greening light.

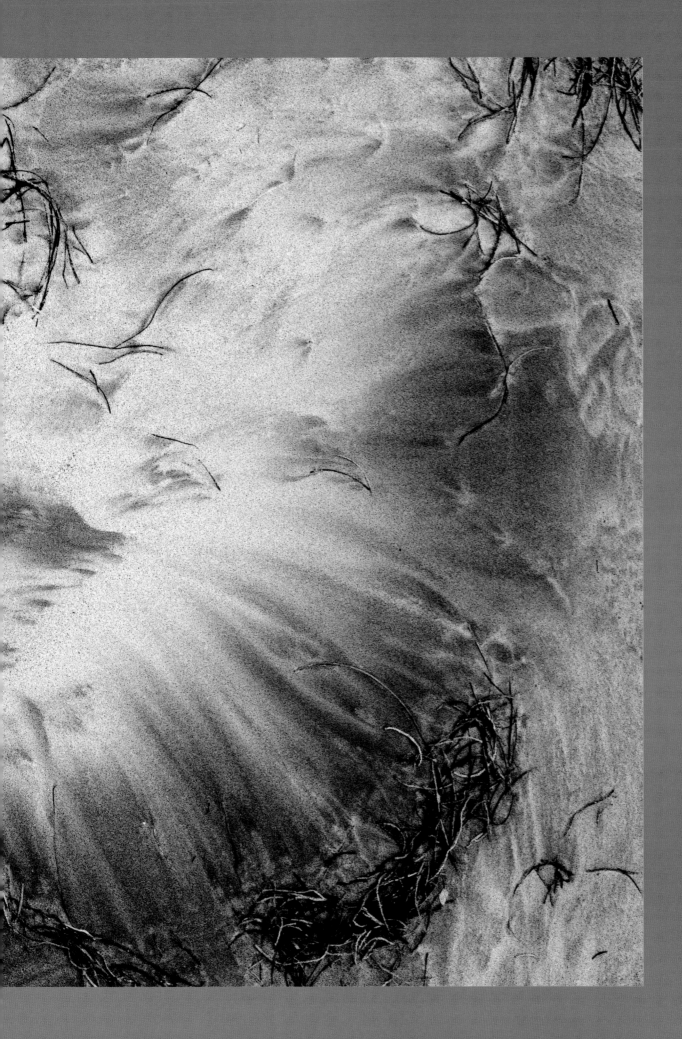

CONTENTMENT

You to me

 and

I to you

 have returned.

Heart scars, once frightfully deep,

are healing with peace.

Despair wanes with each sunrise.

Thwarted by the raining of our hearts,

those disruptions that once overtook us

can only talk to a past

that has fallen silent.

For me, you are all there is,

has been, and will be.

What I shall now become

will, through your love,

be what I've longed to be—

a fire to forever burn

within the glow of contentment.

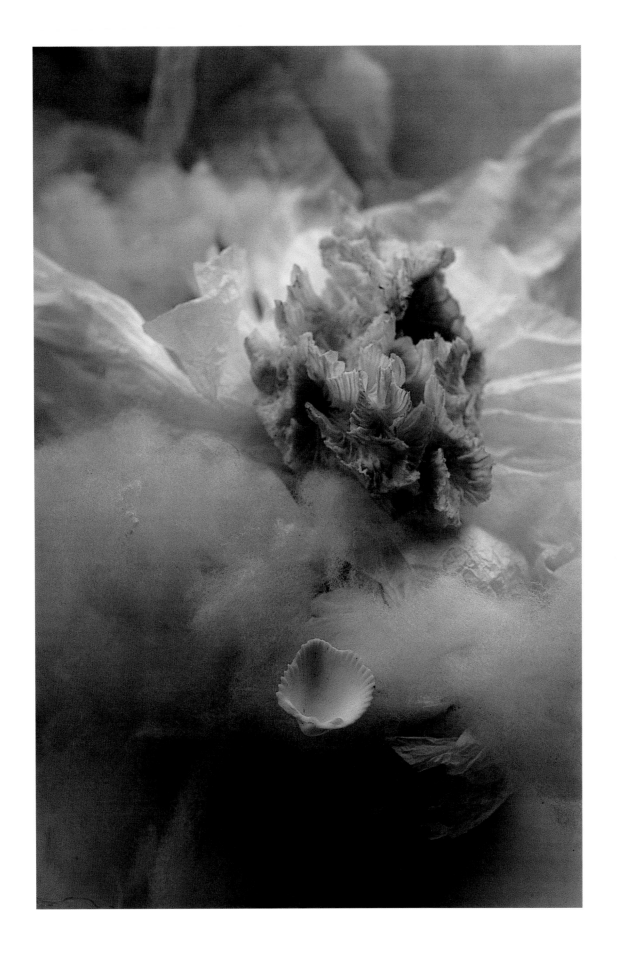

HOMECOMING

A CHILD ARRIVING

Having swallowed our wintry past,
we await the wondrous gift
slowly making its way to us.
I will welcome it in a hurry,
and my heart swells as day by day
 I watch you swell.
I sense the motherlove stirring,
flowing warmly inside you.
I wait—impatiently wait—
for it to soar into birth
like a princely eagle.
Its arrival will oust the uncertainty
of that insatiable shadowy demon,
who, with mischievous ceremony,
chewed up my dreams each night.

Now, here in this place
where spring has buried winter,
the despair that threatened our Eden
is a forgotten word.
Having stolen heaven from the gods,
I feel no guilt for it.
If you would have a star for noon,
it shall be yours.

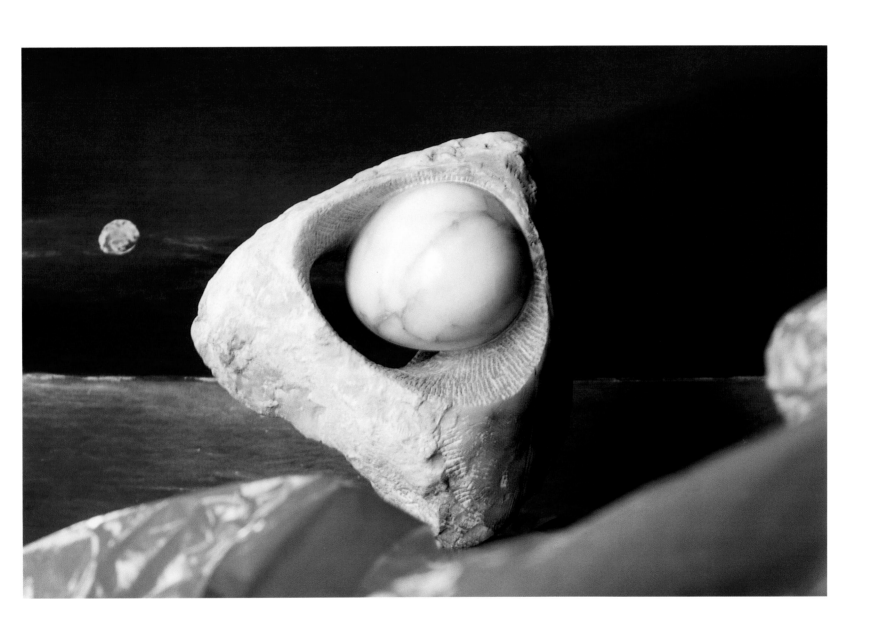

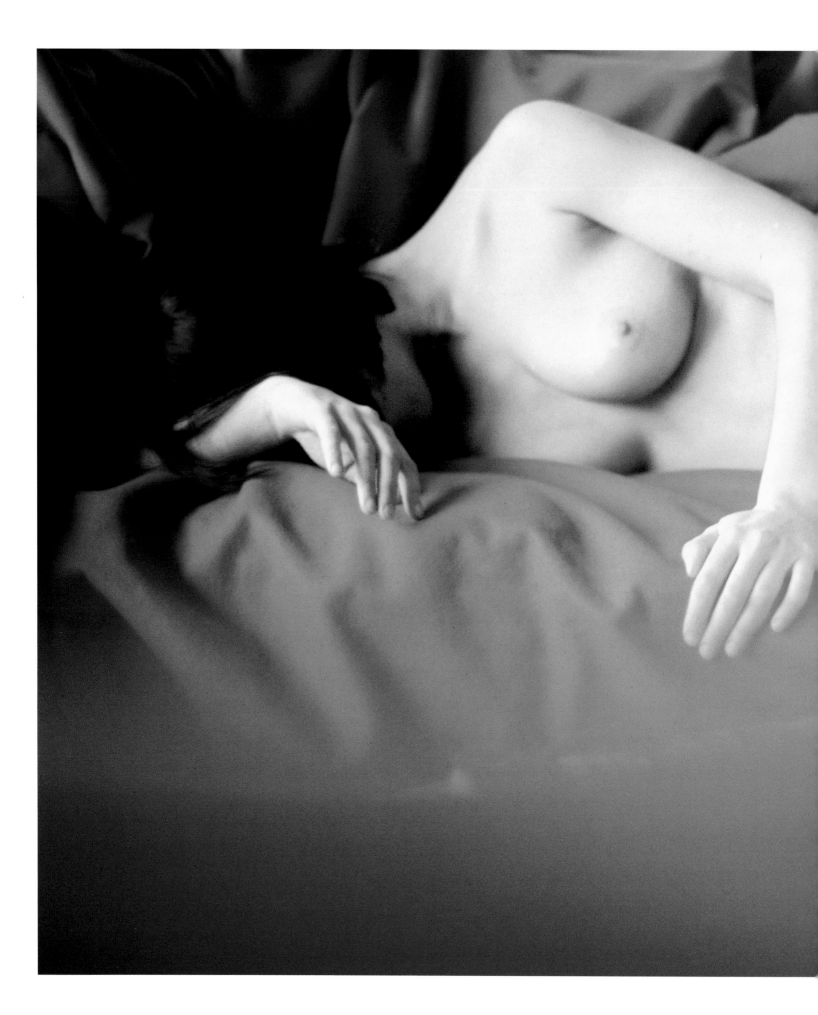

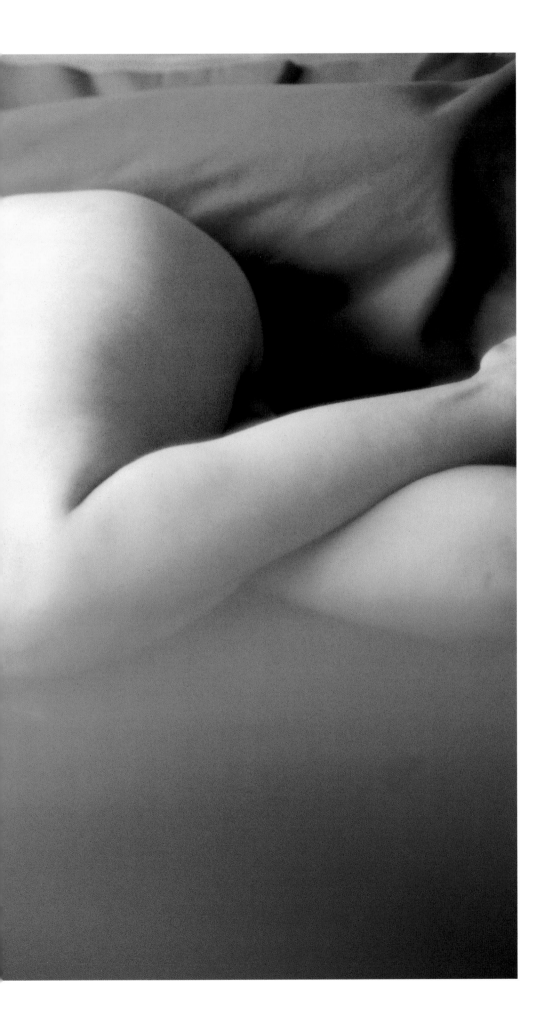

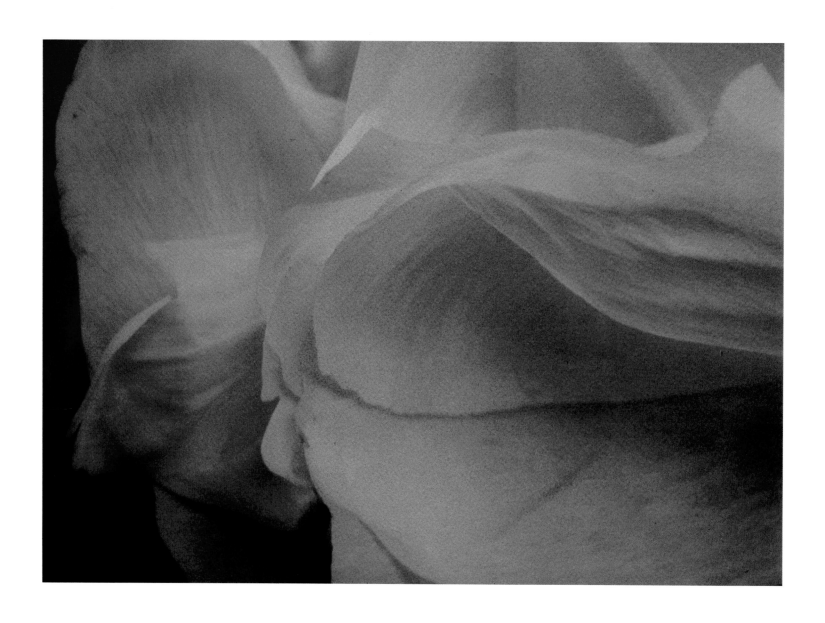

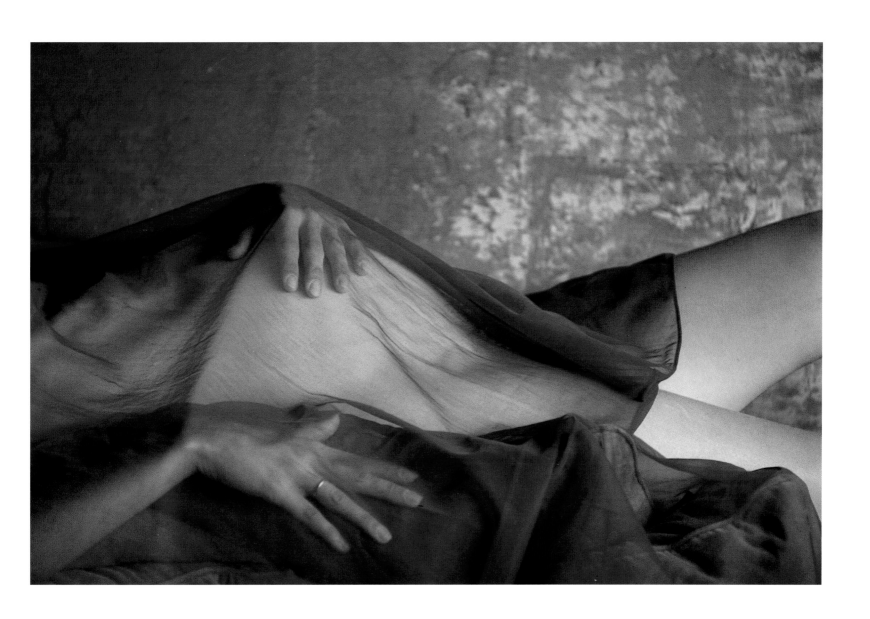

ACKNOWLEDGMENTS

I am truly indebted to the individuals who helped put this trilogy together. A glance back makes me feel that each one seems to have been born to help define my efforts. The lovely women flowed through my imagination like honey, while the camera devoured the secret stirrings of their existence. Many moods danced through the corridors of their thoughts as they gave shape to my feelings. At times they were like dreams, and I'm one who loves to keep turning out dreams.

Poetry, with its slow-moving eye, gave license to many thoughts that baffled me at times. But when it robbed me of peace, I closed my eyes and turned to an old friend and reliable critic, Deba Patnaik. When my eyes reopened, Deba had put me on the right track again. I could never grow used to his absence.

There were two knowledgeable friends who never wearied of the musical consultations. Mario Sprouse hovered close to my piano and keyboards, recording every note as my fingers went—toward calamity or perhaps serenity. He seems to have been at my side for centuries. Then there was Kermit Moore. With his cello hauntingly saturated with beautiful tones, Kermit was always there clearing things up. With pencils in hand, he lost himself in the preoccupation of orchestrating my music and putting it on paper. Later, he wielded the baton during our difficult recording sessions.

Johanna Fiore causes me to be—and keep on being. When she became my assistant ten years ago, I stopped worrying—about negatives, bills, and proper food. She has even taken on the mean task of taking my portrait when one is needed. But her deepest concern is to just keep my life moving. I couldn't count the chores she undertook to produce this book. The gathering in of so many things that made it possible renders her as inexhaustible. So to her husband, John, I present my sincere thanks for having calmly tolerated her dedication to my trials.

Wanting no truck with mediocrity, I welcomed the fullest participation of Bruce Campbell, the art director. From the beginning Bruce let me know that I was in fine company. His sensitivity grants the production a salaam. He thoroughly understood the delicacy of the undertaking and gave lyricism to it.

When the final hours before publication were called to the table, Terry Hackford, my editor, was there. For months, with sharpened appetite and discerning eyes, she had watched things grow quietly. Now, with all the elements being served, she looked at them with hard eyes, dissected them, and before the infinite hour of eating, she pointed out what was digestible, and to those perils that urges one into misleading themselves. Having walked those selfsame streets, I hoped to never return to them. So, trusting the wine of Terry's experience, I filled my glass—then lifted it to hers. A proper tablecloth was spread. Her wisdom had granted me the justice of eating without disappointment.

Gordon Parks

STAR FOR NOON SUITE

For Chamber Ensemble

1. Star for Noon

2. Awakening

3. Longing

4. Solitude

5. Homecoming

Music composed by Gordon Parks

Orchestrated and conducted by Kermit Moore

Gordon Parks, piano

Kermit Moore, cello soloist

Mario E. Sprouse, producer

Printed and bound by South China Printing Company

Printed on 157 gsm Japanese Matt Art

Typeset in Poetica and Universe

Designed by Bruce Campbell

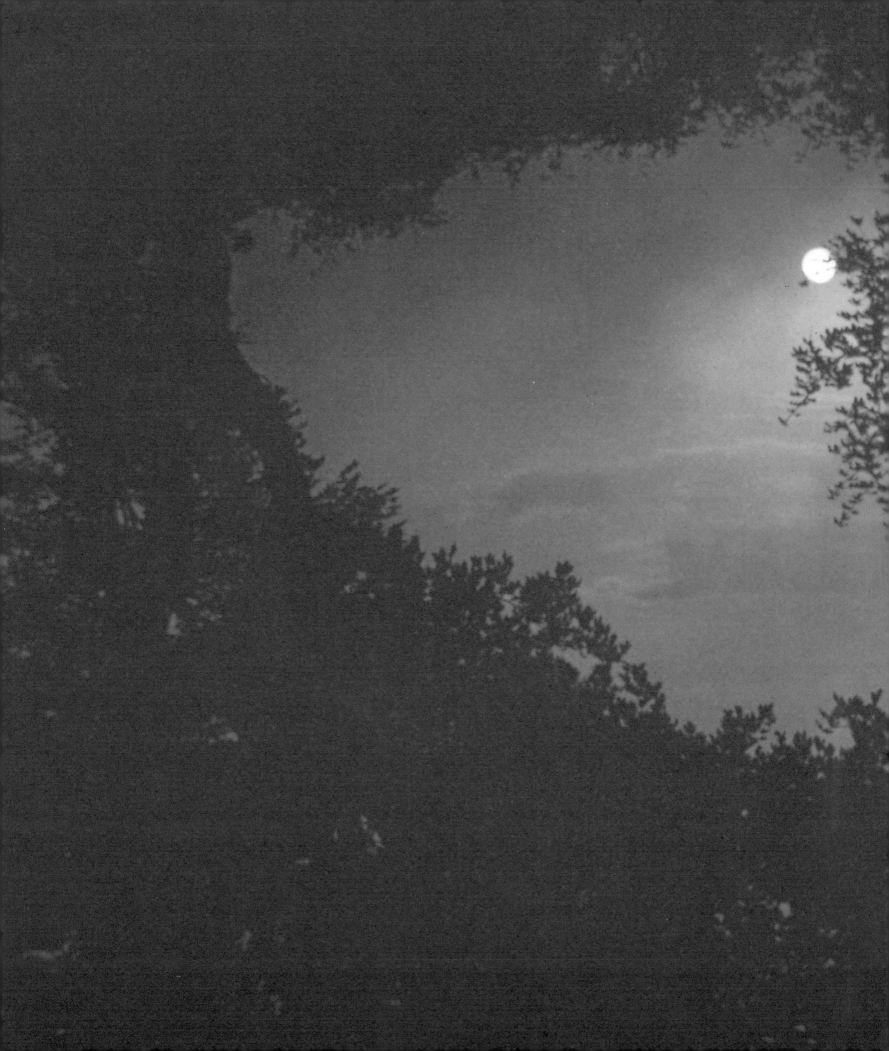